Eduardo Paolozzi

Sculpture, Drawings, Collages and Graphics

An Arts Council Exhibition

Newcastle, Laing Art Gallery, 17 April–16 May 1976
Edinburgh, Scottish Arts Council Gallery, 29 May–27 June
Leigh, Turnpike Gallery, 3–24 July
Wolverhampton, Municipal Art Gallery, 31 July–29 August
Hull, Ferens Art Gallery, 4 September –3 October
Southampton, Art Gallery, 9 October–14 November
Cardiff, Chapter Arts Centre, 4–22 January 1977
Kendal, Abbot Hall Art Gallery, 29 January–26 February

Frank Whitford	Inside the outsider	7
Robin Spencer	Looking backward at the future	15
Wieland Schmied	Bunk, Bash, Pop	21
Eduardo Paolozzi	Iconography of the present	27
Interview between Eduardo Paolozzi and Richard Hamilton		35
Illustrations	Sculpture	41
	Drawings	55
	Collages	75
	Graphics	101
Catalogue		125

Catalogue designed by Emanuel Sandreuter
Filmset by Wordsworth Typesetting, London N1
Printed by J. E. C. Potter & Son Ltd., Stamford, Lincs.
Exhibition Officer, Richard Francis

We are grateful to the authors and editors for permission to reprint the following
articles:
Iconography of the Present by Eduardo Paolozzi first published in the Times Literary
Supplement on 8 December 1972.
Interview between Richard Hamilton and Eduardo Paolozzi first published in *Arts
Yearbook 8*, 1965
Bunk, Bash and Pop by Wieland Schmied first published in German in the catalogue
of Eduardo Paolozzi's exhibition at the Nationalgalerie Berlin 1975
© This arrangement The Arts Council of Great Britain 1976
© *Inside the Outsider, Looking Backward at the* ~~ The Arts Council of Great~~
Britain 1976

ISBN 0 7287 0090 5

Cover: Bunk: Meet the People, 1948 and 1972
Back cover: Bunk: Real Gold, 1950 and 1972

A

Eduardo Paolozzi

Foreword

Eduardo Paolozzi has long been a familiar name; his exhibition at the Tate Gallery in 1971 revealed the extent of his development from the early days of 'pop' art. This exhibition back-tracks on the early work and relates it to the new. It shows that his work has taken the same sources, popular culture and ephemera, but that his present concerns are less literary and more involved with formal invention. The new work lacks nothing of the old vitality, while in both colour and subject matter it is more controlled and sophisticated. Perhaps it would not be unfair to relate it to the development of pop music, from the early American-oriented days of the 50s to the multi-tracked complexity of the 70s. Happily, unlike many of the music groups, the artist is still working prolifically.

We are most grateful to the artist for collaborating with us on this project, to Marlborough Fine Art, and Richard Salmon in particular for their help and to the lenders and contributors to the catalogue.

Joanna Drew, Director of Exhibitions

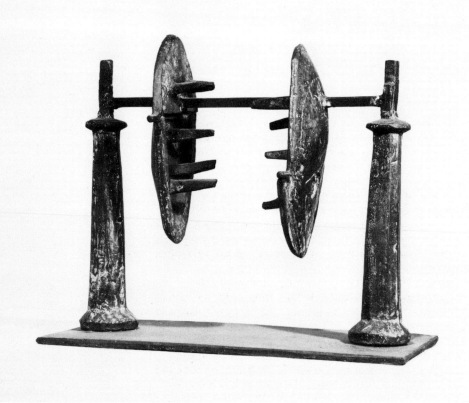

Two Forms on a Rod 1948/49 (2)

Unlike Theda Bara or Nosmo King, Eduardo Luigi Paolozzi is not a name invented to further an artistic career. Nor was the fact that his paternal grandfather was called Michelangelo responsible for his decision to become a sculptor. That happened almost by accident when, newly enrolled at the Slade School of Art, Paolozzi discovered that almost the only unclaimed working-space was in the sculpture studios. It was a happy accident and not only because Paolozzi seems built for sculpting: thick and square with hands like vices. In the sculpture studios of the Slade he was left largely to himself and, unsupervised, could develop a prodigious but wayward talent in his own way and at his own pace.

In spite of his name, face and physique Eduardo Paolozzi is a Scotsman; or rather he is an Italian who happened to be born in Scotland: in Leith in 1924. His parents, from the small mountain town of Vitticuso in the Adriatic province of Frosinone, had taken themselves there (together with the technique of making ice-cream without a refrigerator) in search of a better life. Eduardo grew up speaking Italian at home, being made to feel Italian at school and becoming completely Italian during the summer holidays at boys' camp in the home country, subsidised by the *Bellelli*, the Fascist youth movement.

In Scotland therefore Paolozzi was something of an outsider; but he was an outsider among others of a similar species. For Leith is the rough and tough end of Edinburgh (that most snobbish of Scottish cities where even the accent contrives to sound refined) where the docks or the army defined the farthest horizons for the majority of people. It was something of a miracle that Paolozzi should have become interested in any kind of cultural pursuit in the midst of all this, let alone actually become an artist.

His background was obviously to be of considerable significance for Paolozzi's art. For the toughie from Leith matured as a sculptor at precisely the moment when those genteel, middle-class ideas about art which had operated in Britain for so long most urgently needed a knee in the groin and a butt in the head if British art were ever to become serious. Paolozzi was equipped to administer the medicine in the form of unconventional subject-matter and an

offensively clumsy and brutal style (acquired with great difficulty only by suppressing everything he had learned at the Slade). He had not been brought up on Arthur Mee's *Children's Newspaper* and G. A. Henty's adventure stories for boys but on luridly vulgar novelettes and a rich diet of American films consumed in Leith's picture houses (programme changed three times a week). He acquired more history from cigarette cards than from books. His art appreciation began not in the National Gallery of Scotland but with comic books, and the dialogue of Westerns and gangster movies was more familiar to him than the imagery of Shakespeare, Milton or Burns. Consequently, when he became an art student, he did so without any of the conventional and restricting ideas about the nature of culture which handicapped so many of his contemporaries and obliged them to believe in the greatness of Augustus John and Alfred Munnings and the madness of Matisse, Picasso and Braque.

Paolozzi did not become an art student as soon as he left school. In 1940 war was declared on Italy and he and his parents were interned as enemy aliens. With entirely British logic Paolozzi was released after three months and conscripted into the Pioneer Corps, the martial home of most aliens no longer thought to be a threat to the realm. As his call-up papers did not immediately come through, he spent his days running the family ice-cream shop and his evenings at classes at the Edinburgh College of Art. Always a gifted doodler, he had decided to become a commercial artist. Until he was demobbed in 1944 he took part in the hostilities by living under canvas on the pitch of Slough Town football club and learning how to fry sausages in the wild. It was not all a waste of time. Paolozzi could draw as much as he pleased and came to the conclusion that he preferred to be a proper artist rather than a commercial one and anywhere rather than in Scotland.

He was accepted by the Slade, in 1944 still evacuated to the Ruskin School of Art in the Ashmolean in Oxford. The cultural shock administered by England's most prestigious art academy would have been sharp enough had the Slade still been in Gower Street, WC1; amidst the dreaming spires, not yet even half democratised by the 1948 education act, it was far worse. Paolozzi resented Oxford and most of what it stood for. He disliked the Slade kind of teaching, with its emphasis on drawing from life and the antique and he mistrusted the parochial view of contemporary art broadcast by the tutors: modern art ended with Cézanne and the other Postimpressionists and it was unwise to emulate even these giants who had been dead some forty years.

Ashmolean Museum, Oxford, engraving by J. le Kuex

Things improved when the Slade moved back to its proper home after the war and began to enroll students who had been in the

services. Some of them, with backgrounds even less privileged than Paolozzi's, had become officers; some of them knew nothing about art and had no intention of becoming artists, determined only to have a well-deserved holiday at the State's expense; Paolozzi was no longer alone. Both of his closest friends at the Slade had been pilots: William Turnbull, a fellow Scot from the roughest part of Dundee, had flown Catalinas, Nigel Henderson, a variety of bombers. The three of them shared a healthy scepticism of the Slade, a love of going to the pictures and the suspicion that the most interesting events were taking place in Paris, a city of which they had so far seen nothing, even from the air. They also believed that art was not the exclusive preserve of museums and that visually exciting objects could also be seen in factories, hardware stores and ethnographic collections. At this time Paolozzi took to peculiar dress: strange headgear, a large, curly Meerschaum pipe and thick flannel pyjamas and bright fairisle pullovers.

Catalina

In 1947 Paolozzi left for Paris without bothering to take his Diploma. The Slade had not been a waste of time. It had shown Paolozzi the kind of artist he did not want to become and had provided him with the abrasive atmosphere he needed as creative irritant. Just before leaving the Slade, moreover, he had a small one-man show at the Mayor gallery at which roughly cut cement objects like *Horse's Head* (1946) were exhibited and which made him enough money for his fare to France. In London Paolozzi had become very interested in Surrealism. Now in Paris, Paolozzi, furnished with letters of introduction (arranged by Nigel Henderson's mother who managed Peggy Guggenheim's London gallery), could meet some of the leading Surrealists and learn from them. He got to know Giacometti, became a close friend of Tristan Tzara and saw something of Duchamp's private work, including an entire room papered with maps from the *National Geographic*. Dubuffet was also an influence.

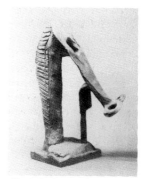

Horse's Head 1946 (1)

Paris was important in other respects. Paradoxically, it provided Paolozzi with the first real contact with America, with which he had fallen in love in the Leith picture-houses. He got to know many ex-GIs studying in Paris who handed on to him the magazines they received weekly from the States. The America Paolozzi had discovered on the cinema screen was a fantasy world, the creation of the Hollywood dream factory. The America which unfolded in the pages of *Look*, *Life* and *Esquire* and especially in the advertisements, was equally fantastic and glamorous, a confection whipped up by Madison Avenue. It was also equally seductive, especially for someone from England familiar in real life only with austerity. From now on Paolozzi began to collect clippings

from American magazines: food ads, glossy cars, airplanes, pin-up girls, anything that appealed to him at the time. He kept them in scrapbooks, sometimes in their original state, sometimes as simple collages. All this material has been and remains a remarkably fertile source of imagery and ideas. Some of it was used at the now famous 'lecture' Paolozzi gave to the Independent Group at the ICA in 1952.

Paolozzi returned to England in 1947. From then on his artistic development was impressively fast, impressive, but erratic. He produced collages reminiscent of decorative Cubism and sculptures which explored some of the areas defined by Surrealism: both delicate wire constructions like cages and more substantial objects like *Forms on a Bow* (1949). At the same time the drawings were reminiscent of Picasso.

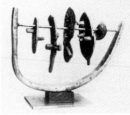

Forms on a bow 1949

His work was exhibited occasionally, but times were hard. Paolozzi was married now and, finding himself in financial difficulties, moved from London to a fisherman's cottage on a remote stretch of Essex marshland. He lived there all the time at first and turned the adjoining cottage into a workshop; but as his work gradually began to sell and as he was gradually offered teaching jobs (the first was in the textile department at the Central School) he eventually moved back to London during the week, visiting his wife and children on the weekends. It is a routine he still maintains, providing that movement between completely contrasting environments and the absolute separation of his home and working lives that seem so essential to him.

In 1952 there were signs that Paolozzi's career was under way: he was one of eight young British sculptors chosen to represent Britain with two established painters at the Venice Biennale. But it was at the Institute of Contemporary Arts that Paolozzi was mostly exhibiting at this time: the old ICA in Dover Street, completely unlike its current incarnation on the Mall, and a genuine meeting-place for artists with its intimate atmosphere and bar. There, in 1954, Paolozzi showed one of his scrapbooks of collages in public for the first time.

More important even than exhibitions at the ICA were the activities there during 1952 and 53 of a group of members who called themselves the Independent Group. They came together to organise a programme of lectures and discussions, some of which were concerned with those art forms created for a mass audience. But the IG was not only concerned with the function and imagery of the popular arts. It also explored the relationships between art and technology and, with many young architects as members,

17-19 Dover Street, home of the ICA in the 1950s

10

pointed towards the first clearly native style in modern British architecture.

Paolozzi's contributions to the IG, and especially the epidiascope show in which he projected some of his favourite images from his scrapbooks and clipping collection are well-known. For the first time he found himself among a large group of people not too unlike himself and with ideas complementary to his own. Together they defined a counter culture which made no attempt to keep a respectful distance between High and Low art or even between art and technology: they provided the tools with which British art was eventually prised out of its provincial shell and propelled in the direction of international modernism.

Between 1953, after the IG had ceased to function, and 1958 Paolozzi's development reached a first climax with a series of bronze anthropomorphic figures (part totems, part robots, part fossilised humans) the surfaces of which are encrusted with the detritus of contemporary civilisation. In them Paolozzi issued a challenge to the polite aesthetic, to the tasteful and craftsmanly attitude which dominated British sculpture at the time. Paolozzi's figures are repellent, threatening, concerned not with high finish but with the results of apparently clumsy handling and ramshackle construction. Paolozzi's reputation, growing apace in both Europe and North America, was at first consequently as a brutalist, as a fellow-traveller of Germaine Richier, Lynn Chadwick and Kenneth Armitage. But as he was soon to show, the intentions behind the sculptures were entirely his and no single style can ever express those intentions completely.

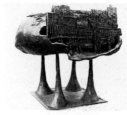

The Frog 1958 (5)

An important stylistic change occurred during and after the eighteen months Paolozzi spent teaching at the Hamburg Hochschule für bildende Künste between 1960 and 62 and it can be quickly seen in a comparison between a work like *The Frog* (1958) and *Wittgenstein at Casino* (1963). The nightmare is over; the zombie has ceased to walk; its place has been taken by the technological totem, clean-limbed and measured in millimetres.

The fact that the change coincided with a protracted stay abroad is not fortuitous. Obvious shifts in style have almost always followed periods in a foreign environment: 1960 in Hamburg, 1968 in California, 1970 in Tokyo and 1974-5 in West Berlin. When abroad, Paolozzi's persona as outsider becomes stronger and the fresh surroundings force him not only to consider them carefully but also provide him on his return with a new eye with which to scrutinise the more familiar England. Paolozzi's is essentially a restless spirit. His heterogeneous art demands a constant rush of disparate stimuli, a continuously changing background of visual information.

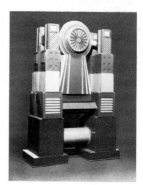

Wittgenstein at Casino 1963 (7)

The change in style of the sculpture was accompanied by a growing interest in other media, especially graphics. Paolozzi had always produced occasional prints (the first, a lithograph in 1950) and was probably the first artist anywhere to use the commercial silk-screen method for Fine Art and to increase its potential by the addition of photographic techniques. In 1964 he began to use material from his scrapbooks and clippings collection to make the collages for a series of silk-screen prints called *As Is When*. Silk-screen had never been used as adventurously before and the portfolio revealed Paolozzi as an artist as resourceful and original in graphics as he was in three dimensions.

Paolozzi's image of himself as outsider provides the key to a hidden layer of meaning within *As Is When*. The life and writings of the Viennese philosopher Ludwig Wittgenstein may seem an impossibly verbal subject for a visual artist. But the biography of the Austrian appealed to Paolozzi because he perceived many parallels between it and his own circumstances and feelings. Wittgenstein spent much of his creative life in England, at Trinity College, Cambridge. In spite of an instinctive liking for the country and its people Wittgenstein was bewildered by its elaborate class distinctions, even in intellectual fields, and its insistence on continuing traditions, however obsolete. He never belonged. He refused to eat at High Table. He rarely had confidence in anything he has done. His teaching method was as unconventional as his thought. There can be no mystery about Paolozzi's fascination for this eccentric émigré.

As Is When and later graphic projects like *Moonstrips Empire News* and *Universal Electronic Vacuum* brought Paolozzi a wider public and the dubious accolade of leading Pop artist. Certainly prints like these and some of the sculptures are related to Pop and certainly Paolozzi's role in the early development of the style was crucial, but the graphics are too wide-ranging in their sources to be pure Pop — or purely anything else for that matter. At the same time sculptures like *Artificial Sun* and *Poem for the Trio MRT* (both 1964) have nothing whatever to do with popular imagery. Like the earlier towers they are made up of casts of partly standard engineering parts welded together. They are more open in form than the towers, more linear in their effect and they play less obviously with figurative allusions.

Although Paolozzi continued to change as a sculptor, becoming increasingly interested in the abstract interplay of form without abandoning the engineering connotations, it is the graphics which seem to dominate the late 1960s and for which Paolozzi was most widely known at the time. Like the other culture heroes of the then suddenly self-consciously scintillating London, he was lionised,

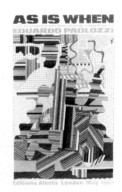

Poster As is When 1965 (62)

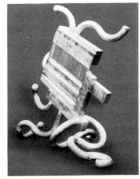

Poem for the trio MRT 1964 (8)

12

flattered and celebrated by the media as well as by the new class of classlessly beautiful people. Appropriate indeed, therefore, that Paolozzi should have been invited much later to design the cover of Paul McCartney's *Red Rose Speedway*, just as Peter Blake and Richard Hamilton had earlier been asked to design the covers for *Sergeant Pepper* and the Beatles' white LP respectively.

Paolozzi's graphics broke new ground, but their very popularity revealed a weakness. Paolozzi has always had a tendency to over-produce and to repeat himself. Many of the individual prints of this period are repetitive almost to the point of self-parody. The sculpture, too, especially those chromium or aluminium-plated pieces like *TWEFX* (1967), are also without the formal or intellectual weight of earlier work.

Around 1970 Paolozzi's erratic development took a new turn. In graphics like *Avant Garde* and *Pop Art Redefined* (both 1971), in sculptures like the *Minimal Box* and paintings like *Jeepers Creepers* (also 1971) he attacked the contemporary avant garde and especially minimalism and the stripe paintings of Kenneth Noland. These pieces are extremely witty, the artistic equivalents of political cartoons, but they suffer, as do pieces like *Tim's Boot* (1971, and originally intended as a comment on the Vietnam war) from a surfeit of ideas at the expense of more visual qualities. As sculptures like the ceiling for Cleish Castle show, Paolozzi is at his best when conferring formal unity on a large number of different elements, when collaging together a variety of dissimilar, already existing units.

If the early 1970s were not a happy period for Paolozzi's development, the move to West Berlin in 1974 brought the artist right back on form, especially in his graphic work. The *Ravel Suite* etchings and *Calcium Night Light* are surely the most original, visually exciting and technically interesting graphics produced since *As Is When*.

Germany eventually began to pall just as all the other foreign environments have done once they have provided Paolozzi with the fresh stimulus he needs. The artist is now back in London, delighting especially in drawing, a medium he returned to in Berlin, where he filled a large number of sketchbooks in pencil amidst the cluttered factory-sized floor spaces of his studio on the Kottbusser Damm.

Paolozzi likes to be surrounded by people and in Berlin the studio was frequently like a railway station for hours at a time. Other artists, photographers, critics and museum men dropped in regularly for a drink, for a meal or to play table tennis (one of Paolozzi's many fleeting enthusiasms). To see it all was to wonder (as one does in the London studio which is almost always as busy)

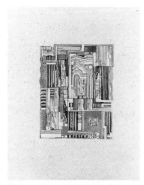

Ci Boure Ravel Suite 1974 (64)

when the artist ever gets down to work. Paolozzi clearly needs other people to provide ideas, encouragement and technical advice. He is charming, generous and appreciative, his parties in Chinese and Italian restaurants are famous, and yet he never gives to friends the feeling that they really know him. Just as he will leave the party to go home to work alone into the early hours so he will always remain essentially reserved and even secretive about his deepest feelings and his attitude to his own art. Even when surrounded by people he has known for years he will always continue to be alone, an outsider, and even though his art is about his life to an unusual degree its surface remains highly polished, reflecting only the outside.

Paolozzi is now 51, an age at which most established artists settle down and consolidate the ground they have already made. Yet Paolozzi continues to experiment and to search for new sources of excitement. In spite of the retrospective exhibitions, the honours and the fame he has never been an 'established' artist in the true sense of the word. He has always had too much of the rebel in him, has always been too likely to do the unpredictable thing for him ever to have provided the public with the safe feeling radiated by established figures. At 51 he is still genuinely an avant garde figure, a true outsider, and at a time when avant gardes are no sooner born than they become academies, that is tribute indeed.

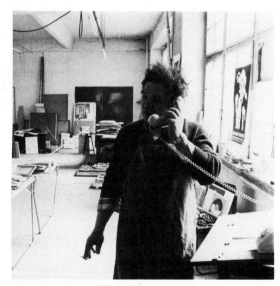

Eduardo Paolozzi in his Berlin studio

Looking backward at the future by Robin Spencer

Paolozzi has no illusions about the priorities other people place on fine art in their lives, and if we are honest we must agree with him. There are many things in life which, from practical necessity, we have to think of as more 'important' than art. In another part of this catalogue he speculates that what is happening in the mechanical world, in architecture and engineering, may ultimately provide the key to a more profound art form. For when he looks at art, Paolozzi is as much interested in the social context of culture as he is in the artefact that is its by-product. In his own art such concerns are reflected in an involvement with man's relationship to the machine; this he sees as a modern metaphor of the Laocoon and a profound symbol of what life in the twentieth century is all about. He never starts a sculpture or print with the intention of saying how 'terrible' the machine is, or how it can 'dehumanise' man; as an artist he has to remain reasonably detached. Quite apart from whether you appreciate some of his subtle irony, or just like his art as art, Paolozzi believes that the artist still has a responsibility to be sensitive to the world about him, and to interpret it as truthfully as he can. There can be no half-hearted compromise with either ideas or materials. The very stuff of Paolozzi's art, the radio parts, cog wheels and machinery which appear in his early sculpture or the charts, labels and reproductions of his later screenprints were once the instantly forgettable tactile and sensory extensions of everyday experience. The sculptures reorientated man's place in the uncertain years of the 1950s, and the prints continued to draw the maps of our ever-expanding mental horizons.

Collage 1963 (?)

Whoever thought of looking at the ephemeral society of Second Empire Paris until Edouard Manet painted the crowds in the Tuileries gardens, the Gare St. Lazare wreathed in steam until Monet set up his easel there? Or the bicycle wheel, bottle rack, and other familiar-unfamiliar ready-mades of Marcel Duchamp? They all focussed our attention on new truths, but also made a prophetic statement about our usual indifference to them. Paolozzi believes that there are still enough familiar-unfamiliar images in the world of non-art to guarantee a positive answer to the old question 'Has Art a Future?', for reproductions and the mass media keep

reminding us of the imagery of the past as well as trying to familiarise us with that of the present. Paolozzi's art is already a particularly distinguished link in this chain, because it represents a constant search for the right metaphor to express and illuminate the complexity of those images and experiences which are often difficult to recognise.

In 1960 Paolozzi said that he wanted to achieve a 'metamorphosis of quite ordinary things into something wonderful and extraordinary that is neither nonsensical nor morally edifying . . . the sublime of everyday life.'[1] In order to succeed in this his job as an artist has always involved him in the study of formal invention. On the surface it appears that his work, in several different media, looks very different at various stages in his career. But underlying all of it, whether in drawings, prints or sculpture, is the principle of collage. For Paolozzi is the best example of an artist for whom collage and the ready made are not only interchangeable and part of one and the same creative process, but more or less a way of life. For a collage is basically a painting made up of individual ready-mades, and a ready-made is a highly concentrated filtered collage which requires the viewer to supply the missing contextual references from his own experience. Somehow the two concepts are often seen quite differently, as if Picasso's first use of cut out paper in a painting of 1912 was part of a different creative process from Duchamp's first ready-made, the *Bicycle Wheel* of 1913. The fact is that one innovation leads naturally to another. Nevertheless, the oversimplification of any creative process, no matter how modest, can distance us from the world that gave it birth. When we attempt to deal with the imagery and experiences outside the world of art it will inevitably lead to misunderstanding and neglect. For the decisions of selection which govern the creation of a single collage are a microcosm of the multifarious choice of visual experience that faces us in an increasingly sophisticated culture dominated by the mass media and the hard sell.

Quite a lot is said of how Paolozzi prefers the Natural History Museum to the National Gallery, the cinema to the art gallery, as if such activities had always been part of a subversive plot to bring down a long-dismantled art establishment, rather than a way of examining with new tools quite orthodox problems which arise in the history of art from time to time. Ever since he grew up in Edinburgh between the wars, Paolozzi has been a voracious collector of ephemera of all kinds, and this material has continued to fire his imagination. It has little to do with 'nostalgia' in the recent revivalist sense of the term, but rather with the sort of interests and obsessions that have always preoccupied artists. Although Paolozzi's collecting can be wide ranging, it is of an investigative and

A section of the Krazy Kat Arkive

objective nature. What began because of a special set of social and cultural circumstances took on new meanings as he matured as an artist. Apart from the iconography of *Moonstrips Empire News* and *Bunk* which both depend on his collection, there is a very special way in which Paolozzi has benefited from a study of popular culture. This has to do with his task as a communicator of visual signs, of colour and of form. For if there is anything which commercial and popular art can teach us, it is surely the way in which visual messages can be directly relayed and received, even when they come qualified by extra, subliminal information. As an artist Paolozzi is especially receptive to such nuances. The most familiar item such as a cigarette lighter or a model sculpture can take on a different life when photographed by a commercial photographer. Once the original image has been re-photographed, joined its neighbours in a collage and screened in colour, it can convey new meanings and associations.

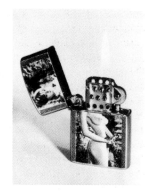

From the Krazy Kat Arkive

In his work Paolozzi has always retained the option of what to leave out, although generally speaking he usually seems to prefer a 'busy' and detailed object to a bare or minimal statement.[2] He feels too that this kind of decision-making is crucial. Of course the problem is more difficult for the social historian, and the art historian too has to come to terms with a much broader spectrum of experience in order to explain the complexities of twentieth century art. It was for this reason that Paolozzi decided in 1972 to donate a large part of his collection of twentieth-century pulp literature, art and artefacts to St Andrews University, to found the Krazy Kat Arkive. The collection is Paolozzi's own source material which he has collected together over the years. It consists of magazines and photographs relating to design, styling, science, technology, the cinema and many other subjects.

One of the opportunities which the Krazy Kat Arkive offers the student of art history is to see comparatively rare images brought together. New meaning can be given to present experience, and by analogy suggest alternative, richer interpretations of the past. The visual material, which amounts to many thousands of images catalogued iconographically, is not the sort of reference collection that can be found in an orthodox library, nor at the Tate Gallery or even the Victoria and Albert Museum, but it provides valuable evidence of the relationship between art and technology, as well as with many other manifestations of contemporary culture.[3]

Consider for example a road research laboratory's use of simulated human beings in their experimental work to recreate the conditions of a car crash. For an artist, here are number of incredibly powerful images that can be explored within the framework of human experience, high technology and art. The creation of this

type of scientific robot suggests numerous considerations which relate to the design and styling of the automobile, and to human biology. This activity carries more significance when an artist makes a sculpture or a painting. Behind any image of man or relating to man, made by man, lies an inter-related network of ideas, forms and traditions that may touch on the robot in literature, painting or the cinema, as well as on the real world of surgery and orthopaedics.

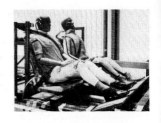

Shift the emphasis to man at war, in Vietnam or Northern Ireland, and you will find the most tragic imagery of the century, far more emotionally charged than what we think of as art. But then turn quickly to the work of Francis Bacon, project both sets of images into the future and consider their relationship then. . . . The same rules can be applied to the art of the past, within our own experience to Picasso's *Guernica,* before it to Goya's *Third of May,* or even perhaps, in a different climate of belief to a Christian martyrdom. The farther back in time we go, and the remoter the culture is from our own, the more difficult it is to interpret intention and unravel visual metaphors. For Paolozzi believes that if we are to deal adequately with the past, we must be able to cope objectively, either as artists or historians, with the problems of the present.

Crash Head (Sam II) St Andrews Version 1971-2

It is true that when Paolozzi was an art student in the mid-1940s, cigarette cards and science fiction magazines were looked down on as being unworthy of serious study, and had no place in 'serious' art. However, in the nineteenth century in France, the same kind of thing was said about Courbet's peasants, the industrial and provincial landscapes of the Impressionists and Seurat's Eiffel Tower. There has always been a basic, deep seated reluctance to see the lofty ideals of fine art reflecting the realities and consequences of growing industrialisation. Today, 'commercialism' and 'technology' are used as dismissive clichés by the people who still complain when the aeroplanes and trains run late. The proliferation of the mass media, like the technology we use but don't understand, has blunted our critical reactions. As images pour from the screen, the message and symbolism of one frame is obscured by the progression to the next. The quality of a commercial artist's work, on a magazine cover or an advertisement, no longer has value or meaning. Because mass production means technology, the image is overlooked and the craftsmanship which went into it forgotten, to say nothing of the social and psychological clues it holds for an understanding of our own culture.

If the analogy between technology and ideas is transferred to fine art, subject matter and techniques are often similarly distanced. The speed of Boccioni's racing car expressed by 'lines of

force' was found generally unacceptable, although a more conventional rendering of a Bugatti by the French poster artist Montaut could be applauded. Paradoxically, it now takes a special kind of nostalgic archaeology to resurrect the image of the poster, so that it will sit in our imagination alongside the progressive vision of a Futurist. How long it may remain there is quite another matter. Not long ago we smoked cigarettes from the Lucky Strike pack designed by Raymond Loewy, but found abstract art 'difficult'. The time space between art and life can be as unbridgeable as the gap between technology and ideas.

The ever present discrepancy between the mythical idealism of art and the apparent commonplace of everyday experience has always encouraged the progressive artist to search for new means of expression, as if like the alchemist, he may one day turn base metal into pure gold. With Duchamp's example before him, and the materials he has chosen to work with, such a metaphor is never far from Paolozzi's mind. In the early 1960s it led Paolozzi to investigate a certain form of abstraction, but unlike some of his fellow artists in England who looked to America for aesthetic stimulation, he chose instead to develop a language of picture making by elaborating further his work in collage.

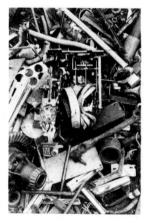

Photo in the Krazy Kat Arkive

Just as Wittgenstein rearranged the structure of language to create new philosophical truths, so Paolozzi juxtaposes the familiar with the unfamiliar to bend our preconceptions about art and its role in our lives. To him art is still essentially about finding new truths through formal invention, often using traditional methods applied to new materials. The language which he established in the 1960s still continues to provide Paolozzi with a rich stock of metaphors for his sculpture. That this language was never far removed from reality is demonstrated by drawings half way to becoming sculpture. They provide 'the rapport on which Paolozzi's art depends . . . from the lure and play of analogies, between a known human image like ourselves and our loves, but embodied in another material than flesh.'[4]

[1] Edouard Roditi, *Dialogues on Art*, London, 1960
[2] The painting which most impressed him for this reason when he was a student at the Slade in Oxford was Piero di Cosimo's *Forest Fire*. For Paolozzi's comments on it see Roditi, *op. cit.*
[3] For Paolozzi's view of the relationship between the practising artist and the art historian see his article 'The Iconography of the Present', *Times Literary Supplement*, 8 December 1972, and pp 27 in this catalogue.
[4] Lawrence Alloway, *Metallization of a Dream*, London 1963.

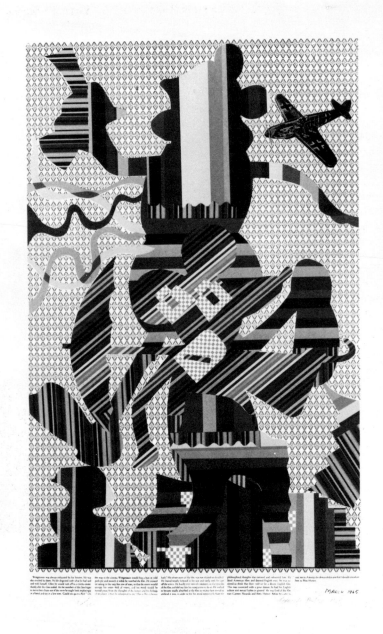

Wittgenstein at the cinema meets Betty Grable As is When 1965 (62)

Bunk, Bash, Pop — the graphics of Eduardo Paolozzi by Wieland Schmied

Eduardo Paolozzi's entry into art history can be dated precisely: it is that legendary show by the Independent Group at the ICA, then still in the Dover Street building, in London in the summer of 1952, at which Paolozzi spoke. But in fact he did not speak at all. He held a lecture with slides and such an extraordinary lecture that he became a sensation and effected lasting change. 'It was the first time', recalls one of those present, the collector Colin St John Wilson, 'that pictures had been shown — blam, blam, blam — without recognisable order or logical connection'. Paolozzi was sparing with explanations — he simply flashed his pictures up on the wall, or, to be more precise, on the heads of the audience.

What sorts of pictures were they? They were not transparencies of his work — or at least not of what counted as his work at that time, or what he thought of as his work, his drawings, his early crude-hewn sculptures, such brutish reflections — they were transparencies, which were to represent the environment of our civilisation: the covers of glossy magazines or science-fiction comics, Mickey Mouse and robots, automobile and Coca-Cola signs, tie and jam adverts, posing stars and starlets, monsters and apes, technology and dreams, publicity and kitsch, an almost encyclopaedic panorama of culture and subculture, of the manipulation of the conscious and unconscious needs of an epoch.

The pictures that Paolozzi showed came from glossy magazines, comics and advertising brochures, were clippings from newspapers, directions for use, book jackets. Individual items seemed to Paolozzi quite significant enough in their original form, so he showed them without any alterations — blam, blam, blam. Yet most of them were collages, however economical and composed of however few elements.

Scrapbook page

What place did this picture world hold in Paolozzi's life? It could perhaps be said that these clippings and collages represented the pages of his intimate diary, in which he faithfully recorded and established what he most liked doing and what most fascinated him.

Paolozzi called these witnesses of our civilisation and its temptations BUNK, later he spoke of BASH. He did not use the word

POP at that time, although it had already appeared on a collage of 1947. It shoots out of a revolver like a balloon caption, like gun-smoke or soap-suds, next to an edition of *Intimate Confessions* and bits of adverts, cherries, a clipper and Coca Cola, making a smoke-screen round the cover girl's brow — a collage that Paolozzi had thrown together from his store in that summer of 1952 and given its first public showing.

Eduardo Paolozzi's lecture with slides — if we can call it that — had the effect of a time-fuse: the bomb did not go off until four years later at the *This is Tomorrow* exhibition, held at the Whitechapel Art Gallery in 1956, in which, amongst others, Eduardo Paolozzi and Richard Hamilton took part. Pop became the vision of a technocratic-automated-cosy future. The beginning of the pop era can be generally dated to these manifestations — and then the spark jumped across to America. But it was still another four years before Paolozzi began to exploit the familiar picture world of sub-culture (directly and systematically) as a source for his artistic work.

This is connected with the development of his work, which reached its consummation at the beginning of the sixties. If sculpture had stood at the centre of his artistic reflections until that time, after it his attention turned equally towards graphic techniques and today Paolozzi's graphic work stands alongside his plastic as an equal.

By 1972, two decades after that memorable meeting of the Independent Group, Eduardo Paolozzi had reproduced, in a portfolio, in their original size, the same sheets he had projected onto the wall. He produced them in the medium of screen printing, of (photo-)lithography and collage and had them published in an edition of 150 copies. The once casual pages of his diary had been uplifted to become the incunabula of pop art and an essential factor in his work. Seen against the series of graphic collections that came in the sixties, *As is When, Moonstrips Empire News, Universal Electronic Vacuum, Zero Energy Experimental Pile* and *General Dynamic Fun,* these early prints are less complex and more simply arranged. They lack the all-embracing context that grips the whole picture and assigns an exact place to each and every detail — and its eventual repetition. Still these fragments and collages retain their attraction because they are characterised by the naive and original freshness which was at work on the artist at the moment he selected them, analysed them and finally brought them together.

Today BUNK functions essentially on two levels: as raw material and a source of inspiration on the one hand and as a finished work of art on the other. We must regard these sheets as works of art — even if on a lower plane than the later great series of graphics — irrespective of whether Paolozzi changed his subject matter in a

Elle from *General Dynamic Fun* 1968

particular instance, produced a collage, shifted the emphasis or whether he accepted a source of ready-made material, because it seemed to him to function artistically without further alteration. And at the same time we must see in these sheets the raw material of his imagination, which occupied him constantly and drove him on to further undertakings.

Everything that he diagnosed as a work of art in looking at our daily civilisation remained, for him, raw material. Similarly in collage, in which the individual contribution of the artist went far beyond merely discovering and selecting. Everying that Paolozzi raised up onto the artistic pedestal with one hand, he kept pinned to the floor of reality with the other, shifting double thought impulses in us in a playfully dialectical process, from above and below.

From *Bunk* 1950 and 1972

Paolozzi's graphics are the result of at least four fortunate circumstances — firstly a specific component of his personality, which, through delayed development or protracted childhood, is only very imprecisely defined. Albert Einstein once said, playing down his genius, that he had developed so slowly that he only began to marvel at space and time, when he had fully grown up, while the normal adult had already figured it out in childhood. In the same way, it was not until Paolozzi was an adult that he began to appreciate the toys he had longed for but never had in his childhood. When he began 'playing', it took on a whole new dimension, which produced an attitude to the world and art. When he finally came to toys, Paolozzi made a highly structured use of them, he took them apart and found in their insides the oracle of new games. Whatever he took up became a toy to him and the toy became philosophy and led to Wittgenstein's word games.

Scrapbook page

The second decisive element of Paolozzi's graphic art was the direction his love of games took. It aimed at the modern technological world, the universal folk-lore of the contemporary which offered itself for immediate consumption in moving and candy-coloured pictures, in the cinema and advertising, tinned meats, the refrigerator, and the playgirl of the time, who promised to serve us through gadgets and machines, as Studebaker or Harley Davidson, as television or robot. A new sense world was to be recognised here, to bombard and dynamise our values, inflame our sensitivity but still leave it unsatisfied.

The third element is closely linked to the second. It is the sovereign creative organisation, which subjects all details, concrete or abstract, to a system of graphics. Paolozzi had his first indication of the organisational potential of his disparate material from the material itself, or rather from the ways it was marketed, got up, packaged and used. In cut out sheets for planes and tanks, build-

ing instructions for Lego-kits, the works of a clockwork robot, stickers for Mickey Mouse, Donald Duck and their synthetic companions, he came on the trail of serialised order mechanisms which corresponded exactly to the material they so attractively offered. Here, in the example of the cut-out sheets and construction plans, he discovered the principle of 'computerising' such material, locking it up in its smallest informational units, which could then be re-constructed into new formations. In relation to similar objective details, these then become abstract, and in the repetition of geometrical elements they can combine and often lead to associative legibility.

Assembling reminders As is When 1965

Contour and inbuilt structure carry on a complex game: as if these tattoos of civilisation had achieved their own independent being. Constantly repeatable patterns isolate items from the consumer world, the details are interchangeable and arbitrary, the kaleidoscopic constellation vacillates between the suggestion of connection and non-connection. Reality appears molecularised and broken down into standardised building blocks, windowless atoms are added to the labyrinths, pop figures dissolve into particles of information and then reform in hazy outlines. One is reminded of the point of Wilhelm Busch's most famous picture story *Max and Moritz*. There they lie, the two villains, dragged through the mill and shredded in pieces, laid out like granularised versions of their familiar shapes, even the crowns of their heads are recognisable; there they lie, flat on the ground, the two-dimensional man, as chicken feed.

Paolozzi's graphics originate as collage — he adds to a background the most diverse elements, quotations from reality and abstract patterns, in a playfully experimental order — until one stands out as the one he has been searching for. This he fixes for the printer. Then begins a new series of experiments: adding colour which will be tested in changing combinations in many different forms of printing.

We have now come to the middle of the fourth element, in which Paolozzi's graphics come alive: the technique of screen printing. Without the speedy development of this technique at the beginning of the sixties through the collaboration of artists like Paolozzi and Kitaj or Hamilton and printers like Chris Prater or Chris Betambeau, the realisation of Paolozzi's complex concepts would never have been possible. It was not until screen printing that the seemingly conflicting component parts of a collage, a screen cliché and a flat coloured surface, photo and design structure, Frank Stella reproduction and banana girls could meet together on one and the same plane. It was not until the medium of

graphics in series that a unified context could be presented, to bring together the disparate details of their nature.

A process was found to portray a picture world. The Cinderella behind the graphic technique, screen printing, never once invited to dine at the table of art, is today celebrating its greatest triumphs, the double-wedding of technique and fantasy, of medium and message.

Translated by Peter Bostock

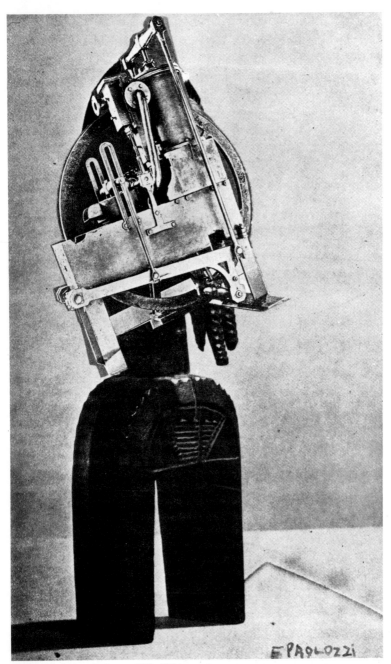

Collage over African Sculpture 1960 (60)

The iconography of the present by Eduardo Paolozzi

I see no reason why the working method of the art historian should not be modified — even consciously — by the problems of selection and presentation which face the artist in today's ever-changing society. The same wide range of subject-matter which is open to the artist is also open to the art historian. A reassessment with more modern tools of much conventional knowledge is part of the twentieth-century programme for the artist, and I think for the art historian as well. Consider, for example, the kind of world tapped by Paul Klee, which, among other things, was the world of the ethnographic. He also drew on microbiology and memory traces, psychological matter and folk art. Here were areas already being defined by an artist, and perhaps orthodox learning is still unable actually to fit all the pieces of the matrix together. Here is something for an art historian who is working on Crivelli as well.

Some twentieth-century art historians, like Pevsner and Friedlaender, have already proved that point, by re-creating in Mannerism a recognisable style of sixteenth-century Italian painting between Raphael and Caravaggio which had not been properly examined for 300 years. The fact is that they did their research in the decades when Surrealism had become an international language. On the face of it, nothing could be more irrational than paintings by Dali or Delvaux, but at the time they spoke the right language to rekindle life in some of the pictures which had exceeded the long-accepted canons of Raphael's High Renaissance. The same ground-rules apply to an interpretation of the work of Hieronymus Bosch, which relates to psychoanalytic phenomena in the twentieth as well as in the sixteenth century.

Of course, Duchamp, Picabia and many others are symptomatic of that reassessment of conventional knowledge. They used what we still call 'Art' as a kind of tool or device to re-examine ideas outside the more normal methodology. One important aspect of twentieth-century art, particularly Duchamp's, is the re-creation of a new legend or a new form of science, where the painting becomes in Duchamp's hands a form of art history rather than a finished object. Take Duchamp's *Green Box* or any book containing reproductions of the collected works of Marcel Duchamp, and

you will find that it is really an art historian's ready-made: paradoxes within paradoxes, which is always an essential part of the creative process. The other thing is that the well-stocked art library, Malraux's museum without walls, has for a long time now been the best way to tackle the communications problem which faces both the artist and art historian. Paradoxically, it is another form of anti-art, where the 'direct experience' has been filtered out. Long before McLuhan asked us to consider the nature or relevance of the media, artists have been questioning the direct experience of art, ever since the racing car was eulogised above the *Victory of Samothrace* and the moustache appeared on the reproduction of the *Mona Lisa*.

Today art historians can do a great deal with photographs, slides and films to show relevant material from an artist's environment; even details of paintings to highlight certain points which, ironically, are impossible to see in the original. Cross-references can be made through scholarship. In one sense the 1972 London Neo-Classical exhibition was concerned with painting styles, but it was also an exhibition about the education of the artist, about politics, about revolution and about the nature of idealism: issues which are always relevant, to a lesser or greater degree, in any age.

At the present moment, time spacing is irrelevant, but what of the historian who, for various intervening cultural reasons, will require in a hundred years' time to assess the impressions made by the Neo-Classical exhibition — or by Tutankhamun — on the generation of the 1970s, on artists and designers? The documents, catalogues, reviews and photographs still exist, but the exhibitions and their very special vibrations have been long dismantled. Basic research material is safe in the archives, and after that comes a kind of research which is based on instinct, an intuition which is almost the same kind of quality which makes a good artist.

I see certain similarities between being a good artist and being a good art historian, in that they both try to present their material in an exciting way, and that because of their passion for the subject the presenters are prepared to go to great lengths to put the information together, even if there is a hint of unorthodox perfectionism in the pursuit of the correct images and facts. The interesting ideas in a picture, or in the biography of an artist, are always the unexpected, missing links. The orthodox art historian puts together dates and facts, but the really exemplary researcher is somebody who goes beyond that point, who finds, for instance, a rare photograph of the site of Mackintosh's Glasgow School of Art before it was built. In scholarship it is that burning question of what is relevant to the subject, and what is irrelevant to the subject — a relentless pursuit towards a New Truth.

Nineteenth-century concepts of art education which, in very broad terms, were perhaps more monolithic than they are now, make it easier for the art historian to say what the direct and related influences were which went into making a picture. An artist would enter the Ecole des Beaux Arts, study under a certain master and produce a certain type of painting; or else he would secede like Manet and the Impressionists. (I still have a feeling that art historians like that; and that in a kind of way, they like to be absolutely certain that the artist they are talking about is of unparalleled grandeur.) But now things have opened up in every branch of knowledge, and the Ivory Tower concept of art is crumbling. Certain ideas, common to the artist who is putting over information about everyday existence and its related artefacts, are equally appreciated by the university student or by any normal perceptive adult.

For Van Gogh and Cézanne the battle was with a fresh optical perception of the traditional landscape, with people and still-lifes; but now the mental landscape is entirely different, so infinitely complex that an almost archaeological exactitude has to be taken in deciding on which of the millions of available images you are going to present, for what reason and in what style. But who, in a hundred years' time, will say that a conceptual artist who avoids these problems is not also a Romantic Realist? For once it is satisfying to leave the problem to an art historian, because it will be his problem in the future.

One of the most difficult things about being an art historian is to decide how much you are going to leave out beyond your subject; for the artist is prepared to do this. And whether the artist takes note of the power station, or the motorcar which zips past his window every five minutes, or the aeroplane that goes over his head, is a complicated question; but surely in the context of art and writings on art, only a tiny microcosm of a much greater communications problem.

There is no reason why an art historian should not concern himself with this type of problem, because there are many sociologists and behavioural scientists who are interested, and well equipped, to do it for him. There is certainly a kind of disease preventing this: you can only relate yourself to a subject in depth when it is in the past; you are unable, in what still might be termed art history, to relate it to the present. This has all the dangerous aspects of a secret society, a form of cultural mafia, which the layman cannot become involved in. For instance: the decorations on the side of aircraft are full of military significance, but they also have a number of social and political implications. It would be useful, for example, for an art historian working on aspects of

twentieth-century culture, to do research at the Imperial War Museum. These are the sorts of problems which students and lay people are interested in, and which artists have been involved with for some time. It is only a modern redefinition of older ideas, in the same way that life-drawing is being reconsidered at the moment.

I recently gave a large collection of twentieth-century pulp literature, art and artefacts to St Andrews University, in order to found an archive which can investigate these aspects of twentieth-century iconology and popular culture, by exhibition and analysis. Most of the material in the collection, which includes magazines on styling and technology as well as science fiction and films, will never be available at the Tate Gallery or the Victoria and Albert Museum. Already there are thousands upon thousands of images and articles which can be drawn on by artists and art historians for the sort of analysis which the complexity of twentieth-century cultural investigation already demands. The roles of the artist and the art historian need not be mutually exclusive. In the nineteenth century an exhibition containing paintings by Velázquez could radically transform the career of a young artist. Today, if St Andrews tours an exhibition of rare film-stills on a particular theme, or an easily assimilated review of aircraft or automobile design, the impact might be just as great.

This type of imagery is not often exhibited, and strangely enough, precisely because much of it is so quickly disposed of by our consumer society, the artist often finds it difficult to refer to. Conversely, the art historian will find when he consults the St Andrews Archive that he has to cast his net rather wider than he might have previously thought, if he is really going to come to terms with the twentieth-century landscape and its related cross-currents, in so many different media. No real art historian sees the development of Futurism only in paintings, but studies politics, war and philosophy, which have an iconography quite dissimilar from the language of analytic and synthetic cubism.

The use of the word 'archaeology' is just as applicable to the art-historian as it is to the artist. The influence of the cinema, and television, of thousands of movies, some good and some bad, has so far as I know never been investigated by the Honours class in a university history of art department — to say nothing of a serious study of the cinema industry, its internal structures and architecture. This is not an argument about 'Is the cinema an art form?' Most artists, and I think art historian too, visit the cinema regularly. Art historians of the stature of Panofsky and Gombrich have already written about it.

Today, classic television footage is being wiped clean, and archivists are working overtime, faced with crucial, almost ideolog-

ical, problems, often concerned with storage, about what should go and what should remain. Already it may be too late for future art historians to take part in this sort of decision-making. It is now possible for the Manhattan telephone directory to be reproduced on two tiny frames, but a phone freak can do without either. The paradox between the pursuit of a technical ideal and the arranging of a simple, traditional exhibition of images and artefacts of our technological surroundings to serve the needs of the humanities, of art history departments, of artists and the ICA is an ironic situation, but surely not an insurmountable one.

The existence of art history and art historians in the universities should reflect a need by academics to gain knowledge and clarification about art and its function within future society, rather than the pursuit of a dry connoisseur's exercise more appropriate to the age of Berenson. Because art history is a comparatively recent phenomenon, researchers regularly have to turn to the writings of novelists, philosophers and scientists, rather than rely on the work of their colleagues. There is every opportunity for art history to remain flexible as a discipline rather than become inbred. Although as a subject it was born out of the need for specialisation, it is, within itself, totally unlimited as a form of creative and scientific interpretation. If it is to deal adequately with the past it must also, if it is to maintain any form of scientific objectivity, be able to cope with the problems of the present. One cannot help questioning whether, in general, it is really doing this.

Here, the duties of the art critic overlap. I find it ironic, for example, that one of the tasks of the art historian or critic is not necessarily to *improve* art, even in a very general way. In the nineteenth century, that was what Ruskin rightly or wrongly believed he was doing. He was not then described as an art historian, but as well as writing about the art of the past, supporting modern artists such as the Pre-Raphaelites and attacking what he considered bad art and design, he also wrote extensively about economics, politics and the nature of war. His reputation may be out of all proportion with the logic of his beliefs, but he provided a focus for argument and opinion. The symbolism of today's imagery does not have general recognition, and artists are not sufficiently committed to a united ideal to support a figure of the magnitude of Ruskin. But there is no reason why an art historian or critic should not at least try to relate himself to contemporary imagery. Its diverse expression in different media can teach him much, even if it is only a lesson in historiography. If, in an age of specialisation, a researcher ignores it completely, quality is bound to be overlooked, and confounded with diversity.

In our time, with the increase in leisure facilities, there is a

particular kind of important and crucial problem emerging in art. I think art can act as a catalyst for many different types of people being involved with many different forms of activity. There is a profound psychological basis for the great difficulty we experience in gaining knowledge because of easy availability: free libraries, free museums, even educational grants, all coming together in a culture, which together go to make up the very texture of our culture. Unless there is a certain kind of intricate balance between them all, it will not work. The way one assimilates knowledge, the actual methods, is very influential, sometimes in an almost subversive way.

The Open University will produce a different kind of scholar from the graduate of Oxford and Cambridge. The same goes for an oil painting: whether it is in a works canteen or the National Gallery. The technique of the exercise always plays the most important part; and it is the context of the school or the university which provides the initial, long-lasting impression. We can all remember the bad colour reproductions of Impressionist paintings when we were at school, but the decision of what kind of image went on the wall ultimately reflects the influence of art history. Questions about learning methods and visual responses have more bearing on our future cultural and conceptual thinking patterns than the original question of the art historian's professional capacity. After all, you can write down how many types of art historians there are, in the same way that you may come up with a large number of different types of artist; but, paradoxically, if you can agree to a definiton of what a good art historian or a good artist should be, you will find that there are never enough of them.

I like to think that, unlike a lot of ephemeral art criticism, the right sort of art history will not become bedevilled by forms of cultural elitism. If it can preserve a conscience for the present and the iconology which relates to it, there is no reason why it should. I sympathise with Tom Stoppard's bemusement at literary professors analysing the ink in his full stops, but at least they are involved with expressing — however artificial and wide of the mark Mr Stoppard finds them — ideas based on a knowledge (obviously *too much* knowledge) of literary history. They are able to draw on a discipline which, unlike that of the history of art, has evolved over many years. Their analytic passages of fall and cadence in the text of a play intended for public performance are (over?) punctilious: but the average art critic is unable simply to describe the label on a soup-can, let alone see the symbolism in a more complex image, or its significance within the context of the history of art and ideas.

Writing about verbal language brings over-exposure; the gulf

between the written review and the visual image is still unbridged. Until looking at pictures becomes more of a group activity this will always be the case. But the art critic has a part to play in this, or should have, which is second only to the artist's contribution. This is the degree of commitment to his subject-matter and a corresponding method of describing it. It is difficult to dissociate the art of Delacroix from the writings of Baudelaire; Manet's Realism from the prose style of Zola; Picasso's synthetic Cubism from the hermetic approach of Apollinaire, or Futurism from the pen of Marinetti (who must surely rank not just as the compiler of manifestos, but as a special kind of critic, and subsequent art historian, in his own right).

Today, paintings by Monet, Renoir and Cézanne, artists whom Zola supported, hang in the homes of millionaires and in the great museums of the world. We easily forget that the radical subject-matter of their paintings was once totally unacceptable to critics and public alike. The steam locomotives, suburban factories and café bars are still there in the paintings of Monet, Seurat and Toulouse-Lautrec, who were among the first to paint them; but now, as if by magic, the real meaning of their truly modern subject-matter and the way in which it was presented has been totally forgotten. In the second half of the twentieth century the balance between art and society has changed so dramatically that not only do we easily forget the commitment of Impressionist iconography but we are completely indifferent to the symbolism in our own age too. Because the iconography of our everyday life is over-communicated, not only does it seem impossible to analyse but it has become difficult to apprehend as well.

I think that if a critic did his research properly, and wrote honestly and at length about some of the safe aesthetic systems which have passed for English art in the past thirty years, he would stand every chance of being removed from the newspaper by its subscribers, as was the case with Zola in the nineteenth century. There is no need to leave this type of distinction to the next century when a more scientific analysis could be done efficiently now; and perhaps in the same way that good art does, it might bring an enriching awareness to our culture. Because of a number of vested interests concerned with fashion and a dubious feeling for a form of spurious modernity, most art critics are unable to say whether a picture is simply good or bad. Often working within a structure of outmoded aesthetic values appreciated only by himself, or a misguided belief that such values can still be applied, the art critic invents some more of his own; and his review dies on the page, communicating with no one.

It is of course a commonplace that people do not mind being told

what they do not know, but take very strong exception to being told what they do know. Unless a critic uses language which is as recognisable and uncompromising as the imagery which he describes, who will do the job for him, and who will stick his neck out to say whether the artist, in his view of society, has done his job well or badly? Again, if you agree on what makes a good art critic, you will find that there are never enough of them to go round. For unless the trio of the artist, the art critic and the art historian realise that their ivory towers have long since crumbled away, there will be more commentators, of a younger generation than that of the Inventor of *Civilisation*, ready to draw a discreet veil over the realism of our world and its multifarious symbolism which, with any luck, will be here for some time to come.

Interview with Eduardo Paolozzi by Richard Hamilton

R.H. There has been a big break in your interests over the last few years. At some point you changed from an interest in things that had an archaic quality, in things that looked as though they had been dug up out of the ground, to things which looked fresh, new — like twentieth-century technology. Did you have a moment of decision when you made this transition, or did it just happen slowly in an un-selfconscious way?

E.P. The 'archaic' earlier bronzes you probably have in mind were done by pressing objects into a clay bed and using these actual embossed sheets to make into figures or heads. I was trying to use a process which was sort of mechanical — which is, that one wasn't actually using a handmade look. The archaeological look you refer to was rather accidental. There was a deliberate attempt to make these images with actual real things, I've been trying to get away from the idea, in sculpture, of trying to make a Thing — in a way, going beyond the Thing, and trying to make some kind of presence. But usually when one is up to one's neck in one way of working, one is thinking of another possibility. I was led to the new possibility, which is using engineering techniques, through the other method.

R.H. You say that it is in some measure the technique that makes the look of the work; whether it's lost-wax process or this process of building up engineers' forms, almost sometimes standard components, you say that it comes out of the technique. On the other hand, when I first knew you, fifteen to twenty years ago now, you spent a lot of time in the Natural History Museum. I imagine that you don't spend as much time in the Natural History Museum looking at fossils and old bones as you now spend in the science museums.

E.P. That's true, but that was just part of a period which was a leftover from Paris. When I went from the Slade directly to Paris, there was all the Surrealist investigation I engaged myself in, and there seems to have been in Surrealism there an engagement with natural history — Max Ernst's *Histoire Naturelle*, for example. But while I was actually at the Slade I used to dismiss the life room and go to the Science Museum and draw some of the machines there. I

did this more or less instinctively — there didn't seem to be any reference to it; one was unacquainted really with the modern art reference to the machine. Then there seemed to be something like a lack of knowledge, and certainly the kind of people that one was at school with didn't quite realise why one went to draw machines. It was a sort of instinctive idea. But I still have an interest in natural history. It has its own ortho-natural laws. To try and make what might be called an abstract sculpture with forms which referred to shells and things like that, I still think that one could make a significant sculpture using orthodox techniques which refer to natural history. One could easily have the right ideas but the wrong approach and vice versa.

R.H. How much do you think you owe to the technique of collage? It strikes me that all of your work comes out of the techniques of collage, the idea of collage, that you put things together, even if you have made them yourself, not necessarily taken them from different sources; even when you are working with your own homemade material, you tend to break it apart before you put it together again. Do you think that when you are making a sculpture you tend to use collage techniques even for sculpture? I mean, even in your most recent works you make separate elements and then assemble them — it's Meccano work, whether it's drawing or sticking bits of paper together or making bronzes by lost-wax or by using constructive techniques.

E.P. Yes, that's true. But the ship, the aeroplane, the motor-car are all made from components, component parts really. They all have to be constructed, and one uses this same means. But there is also the other idea in collage, like using coloured paper, etc.; it is a very direct way of working — cutting out sheets of coloured paper, for example. One is able to manipulate, to move, and use certain laws which are in a way blocked off if you try to do a pencil drawing, say, and then fill in the coloured areas. It's the same too if you use a direct analogy. If you want to make a metal box in sculpture, there is a traditional way. You can supply a plaster block to the foundry, and going through the lost-wax techniques you will eventually get it back in bronze. But there is another approach, in sheer engineering terms: you cut an aluminium sheet into six parts and weld them together, and you have the metal box. Rather like using a Land camera to take an instantaneous photograph. The emphasis really is on the idea of directness, the way I see collage.

R.H. You've never used any of the traditional sculptors' media. You've never done modelling pure and simple with clay, and you've never done any carvings with mallets and chisels and that kind of thing. When you have used clay you have always used it as

a means of making impressions; it's a kind or printing technique rather than a modelling technique.

E.P. Well, this again is directness. By supplying a work to a foundry in wax you are already cutting through some of the original processes, and you also have a greater fidelity to detail, as well as the idea of wax, which is a very flexible material really. But the idea is really directness, to try and get to the idea as quickly as possible.

R.H. Another thing which makes you unlike most sculptors is the way in which your work cuts across all media. In a way you are as much involved in painting as with sculpture. You are concerned with colour, drawing techniques, drawing not as sculptors' drawings but also drawings for their own sake. How do you feel about this 'universal man' aspect of the artist?

E.P. Well, I think one might perhaps be able to reach an ultimate, which is the drawing together even closer of painting and sculpture by actually painting the sculpture itself. There is another possibility, with a silk screen, which is something I am involved with and have been for a long time. After the screen is made up, certain geometrical ingredients, such as variations on the square or the curve, the stripe, the circle, could be applied by the transfer process to the geometric solids of the sculpture, so that you have geometry on two levels. This I think would be an ultimate of a kind. I think that modern sculpture of the best kind has been in and out of the idea of the painted sculpture, approaching the point where you can't distinguish between painting and sculpture, where they cross over in an original way. This would be a goal for me.

R.H. Your present source material is very much in the world of science. Your favourite magazine is probably the *Scientific American*. You are concerned with mathematical ideas at the purely visual level — your education doesn't permit you even to know very much about the mathematical structures of these ideas — your concern is simply with liking the way one set of ideas is translated into a model or one set of ideas is translated into a graph. It's the visual side of all this material that interests you, I suppose, more than anything else. Or do you want to go more deeply into the thing?

E.P. It is debatable whether one can have a totally emotional attitude toward science in the same way one can have a totally emotional attitude toward nature in general. Tied in with the visual interest is the desire to try and find some kind of clues outside of the orthodox art channels, including outside modern art, outside contemporary zones, some kind of means of constructing something without necessarily resorting to programmatic art — to try and use geometry toward an original art, a personal angle.

R.H. Besides the change in your materials and in your general technical attitudes, there has been a change in subject matter. The earlier sculptures, and a lot of your earlier drawings, took humanity as subject matter. They were men or some indefinable but manlike organism. The recent things have tended toward mechanical subject matter. There is an aeroplane, or buildings and that kind of thing, a table, the engineer's table — was this a decision that you made or something that happened?

E.P. There is also a difference of environment, in the sense that even previous to what I call the waxwork period each piece was more or less a studio-bound object. The entire fabrication was done in the studio. The new work is done in a proper engineer's place, principally in the welding workshop. Part of the situation now is that one is trying to go for personality — which in a paradoxical sense may become anonymity. Anonymity in a sense considering all other works done under similar conditions. One has a reversal which is interesting — by risking anonymity, one may find personality. I am using anonymity in the sense that the actual raw materials, when they arrive and lie around the floor of the workshop, are things that nobody would give a second glance. I don't think people would actually identify them directly with art. Even in the old days a wax sheet always seemed to look like art — I mean the actual minute details looked like art. But now one is using flat strip angle channel, and part of the battle now is to try and resolve these anonymous materials into — one doesn't necessarily want to make something which is totally dead-pan — but to try and resolve them into a poetic idea really, such as the mechanic's bench. The mechanic's bench or the aeroplane — I really try to identify these materials with a thing seen.

R.H. You say that all these little fragments in the lost-wax process that you used to make the earlier bronzes had the quality of art. This is probably because your hand was still very close to it. Now that this close identification with the studio is beginning to be removed, your hand perhaps very rarely touches the object. It need never touch the object; you can do it all by instruction. Is this something that you feel is a valuable part of the concept of your recent productions?

E.P. Well, this elimination comes in connection with the whole new kind of process, which is itself a process of elimination in a sense, of eliminating steps and getting directly to the idea. But if you have to revert even to a box, one has — also referring back to the idea of painting the box, or even making an arrangement of boxes — one has always, with this smooth look, the possibility, as I said, of transfer printing on the surface. I see this elimination in

connection with using curves and bands from some kind of simple formation of elements; one is dealing with quite colossal implications.

R.H. It has always seemed to me that you have had a very rich eye, that wherever you go you are on the alert for visual stimulants. Walking in Woolworth's or walking through the streets, it's always you who notice something that ought to be looked at again. I tend not to use my eyes when I walk around; I only think of visual things when I come to a studio. It's perhaps the collage technique again; you are looking because this is the raw material for your work, or something which is different from other people's attitudes. Are you very conscious of this need to look, to be on the alert for the odd stimulus?

E.P. Well, I think in that statement there are perhaps three loaded ideas. There's one which is observation or experience, and there's another which is perhaps mixing up the idea of intelligence and being well informed; but there is also this thing of having a good eye — which I would think would be terribly against one, somehow. The word rejection is important here, I think. To reject as much as one accepts, I think, is part of experience. I mean, one might be moved by sections of Woolworth's — such as the kitchen section, with more and more plastic objects, yellow pails, bright red garbage tins, and that kind of thing. They are marvellous, and I've got to the point of recognising the whole total experience as being the best experience — the best in that one has to try and evolve a system on one's own beyond that result. This means that my previous attitude toward, say, the ready-made is now fast disappearing; I see the ultimate idea as being beyond the ready-made. I mean, in the aeroplane, for example, I have just used a wheel which I designed and a Timken bearing which represents the engine. It's like a little pepper amongst the geometry. There is also a hint of window, a square section which is like windows. But some of my recent sculpture is entirely evolved from geometric means; there are no ready-mades whatsoever.

R.H. How about the mythology of the subject matter? You sometimes use titles derived from Greek mythology.

E.P. I can think of only one instance, *Diana* — an engine. I was trying to make a specific image which depended partly on the real radial engine and partly on a certain casting designed by me — it had a form of edging which was slightly suggestive of edging in the thirties. The title was supposed to help put over an idea. Early forms of society worshipped an image or a symbol which represented some dominant force, and I see something related to this today when one does a precise or specific image which represents

in a small way the kind of man-made forces which contribute to certain man-made articles I am involved with. In a way it refers to the idea that all sculpture really is man-made objects, so that whatever you make in a sense must refer to the other experiences. There is this other word too with a capital M — Mythology, not Mathology.

1965

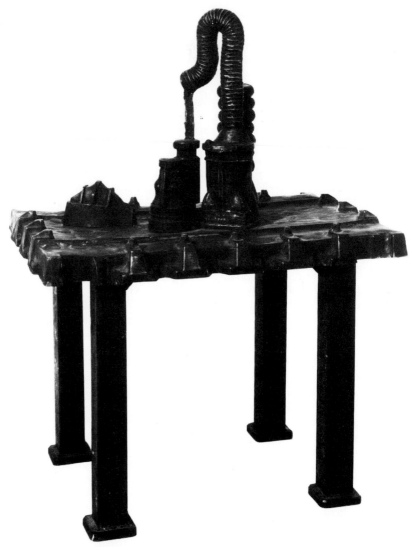

Bronze Table 1974 117×89×66 (not in exhibition)

Sculpture

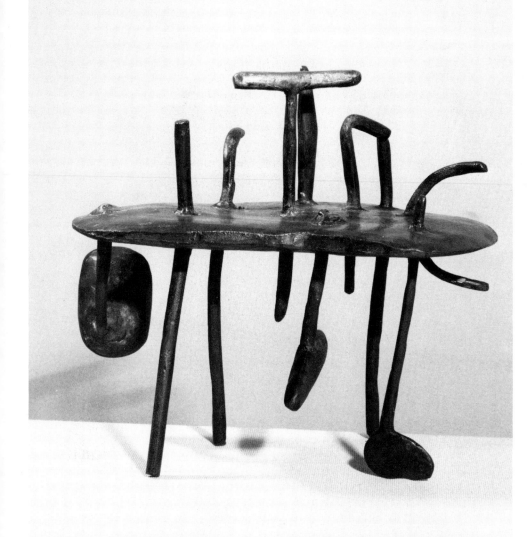

Icarus 1949 (3)

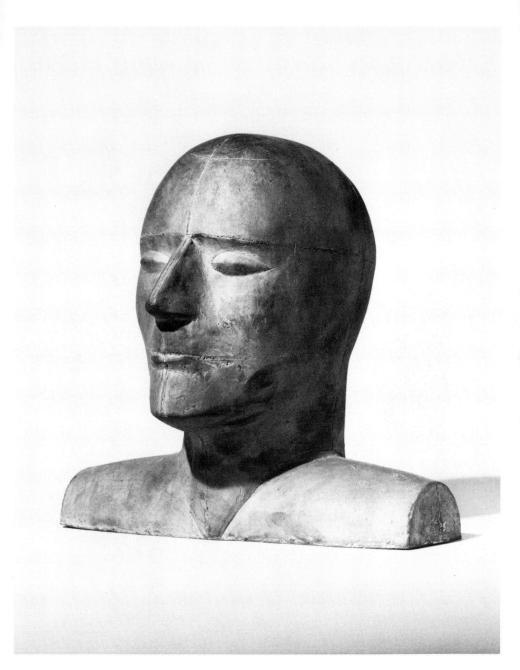

Mr. Cruikshank 1950 (4)

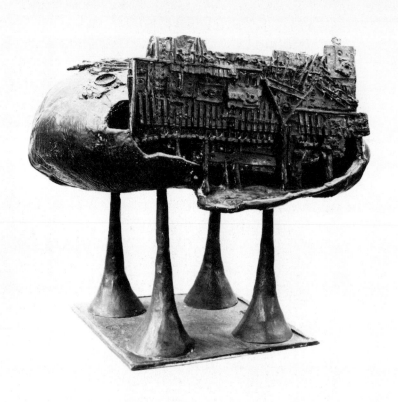

The Frog 1958 (5)

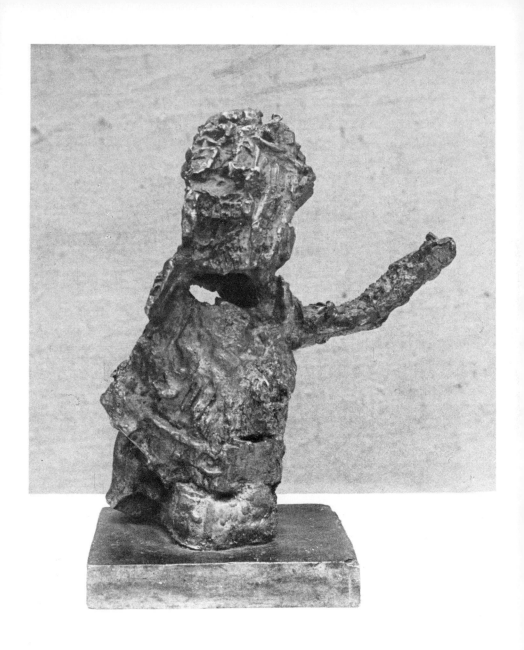

The Old King 1963 (6)

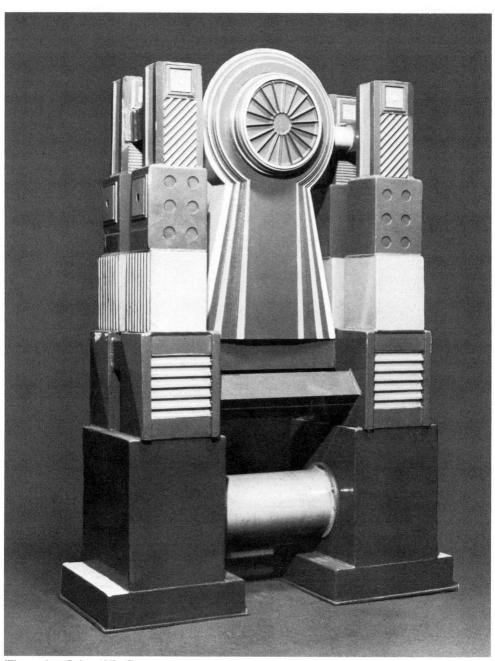

Wittgenstein at Casino 1963 (7)

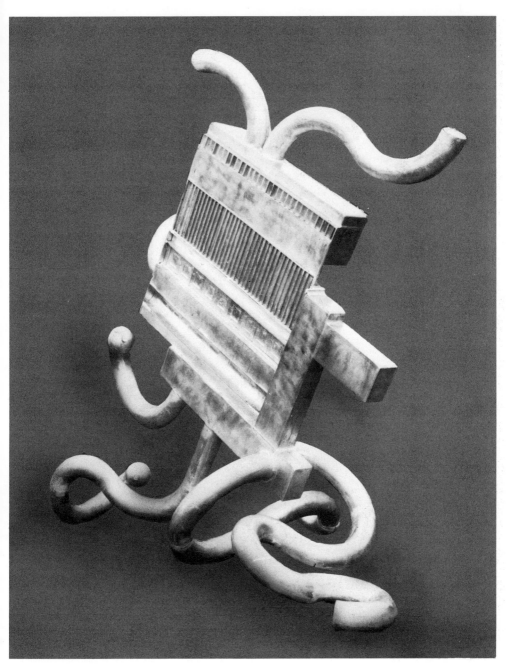

Poem for the Trio MRT 1964 (8)

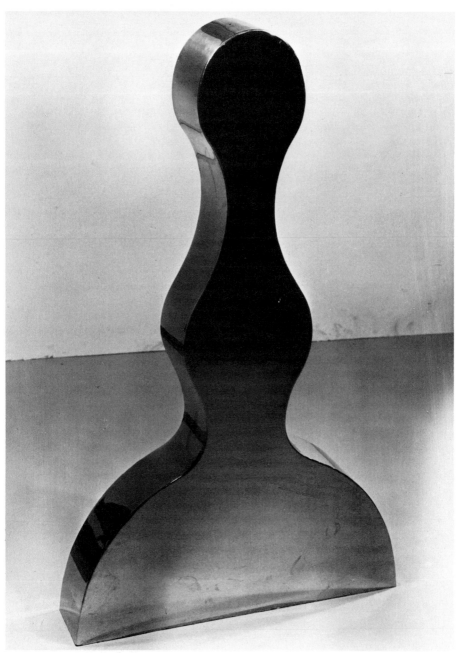

Dollus II 1967 (9)

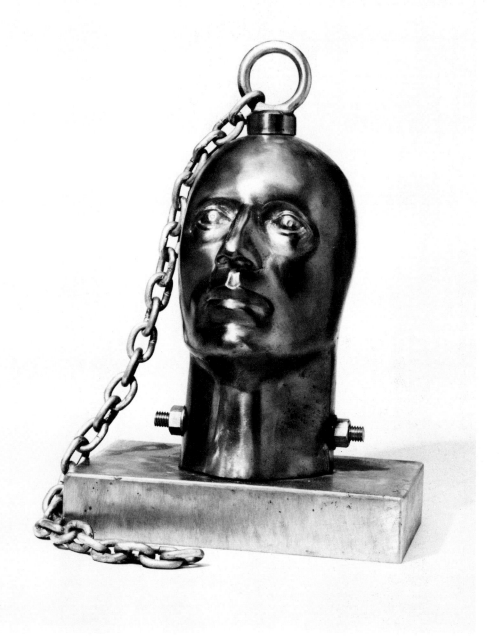

Crash Head 1970 (10)

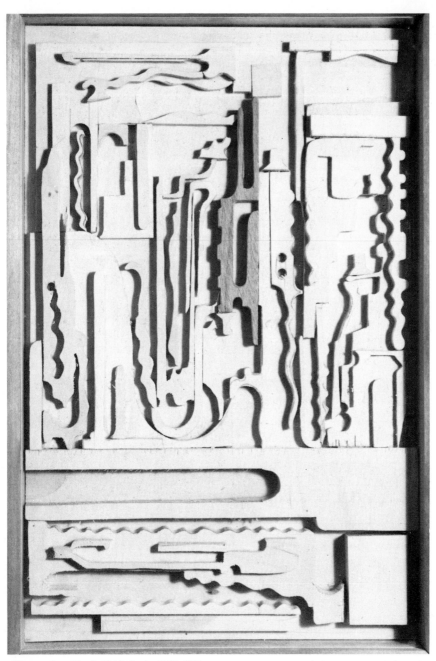

Maquette for ceiling in Cleish Castle 1972 (12)

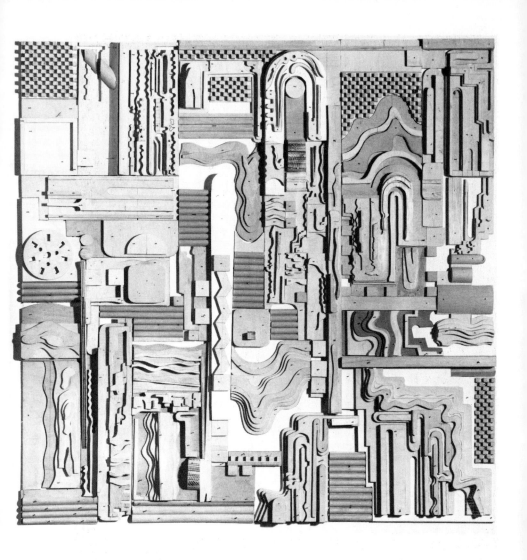

Maquette for ceiling in Cleish Castle 1972 (13)

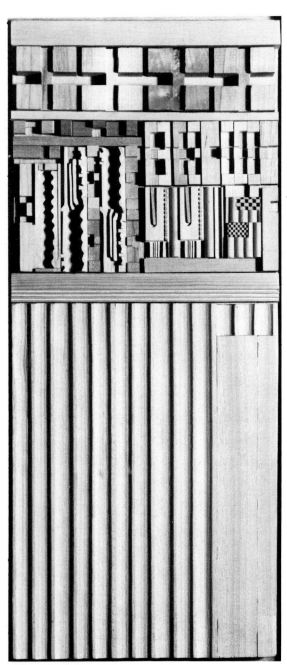

Moniz 1975 (18)

Le tour du Monde 1975 (14)

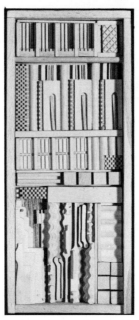

Malduq 1975 (16)

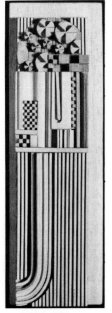

Zutrubars 1975 (15)

Acarett 1975 (17)

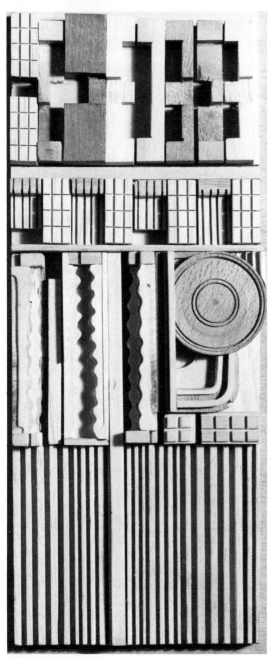

Gas Taut 1975 (19)

Drawings

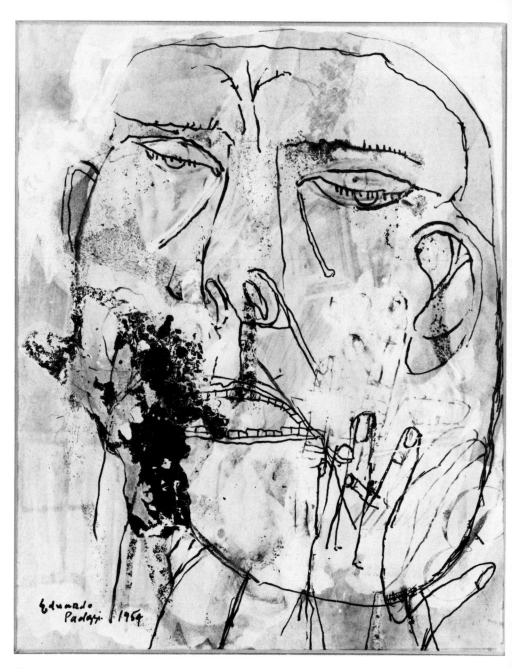

Man smoking 1954 (21)

56

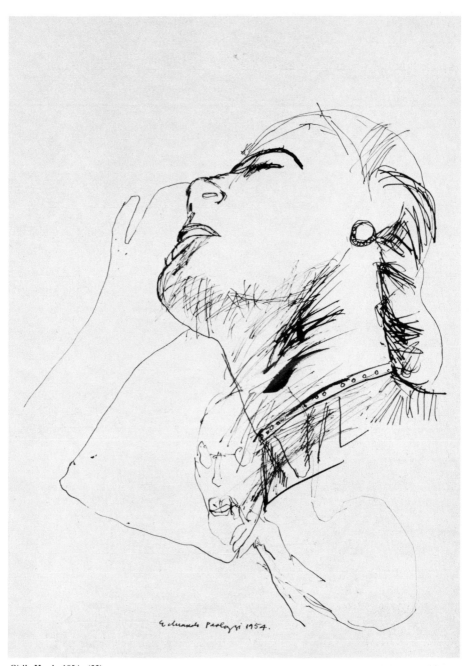

Girl's Head 1954 (22)

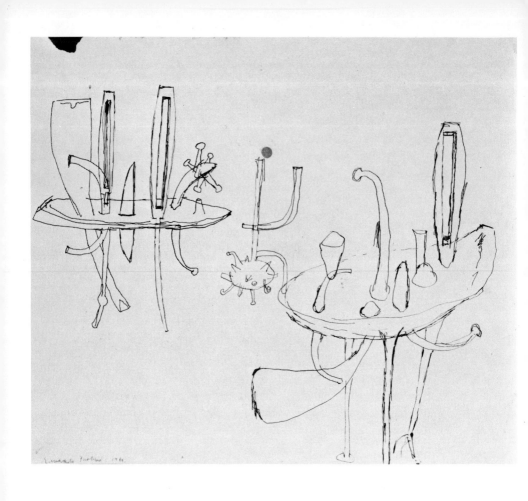

Study for standing sculptures 1949 (20)

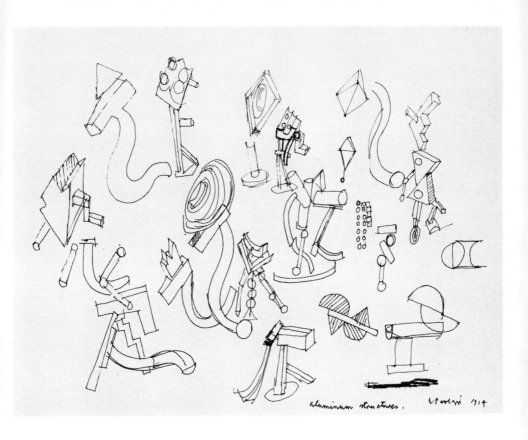

aluminum structures. Chadwick 1964

Aluminium Structures 1964 (24)

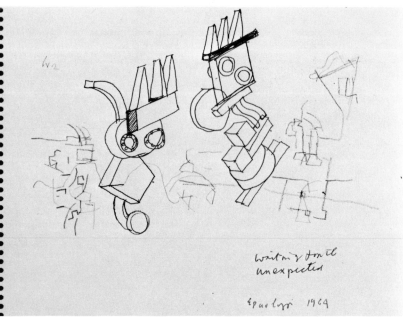

Waiting for the unexpected 1964 (29)

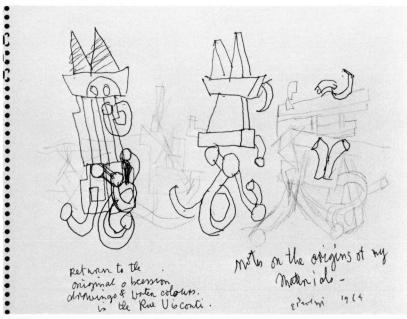

Notes on the origins of my materials 1964 (32)

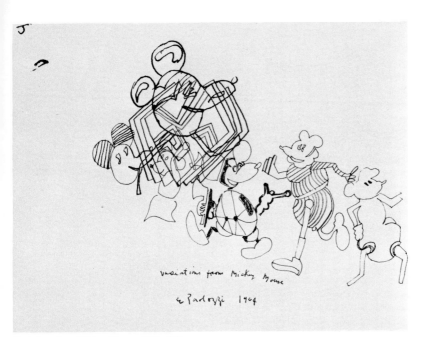

Variations from Mickey Mouse 1964 (25)

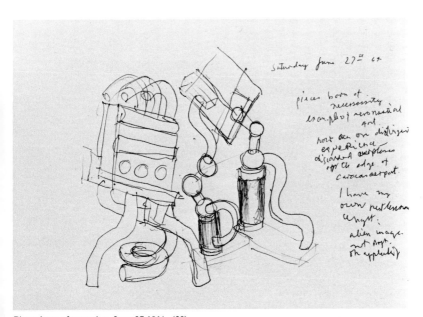

Pieces born of necessity June 27 1964 (30)

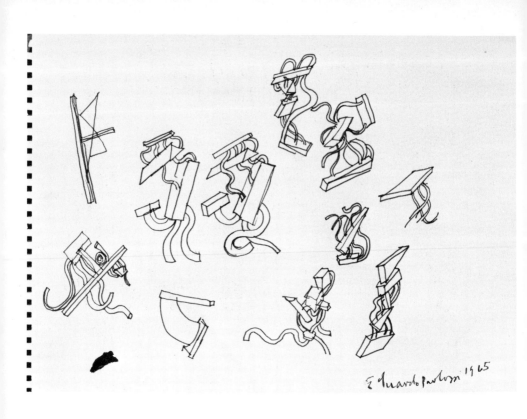

Study for sculpture 1965 (33)

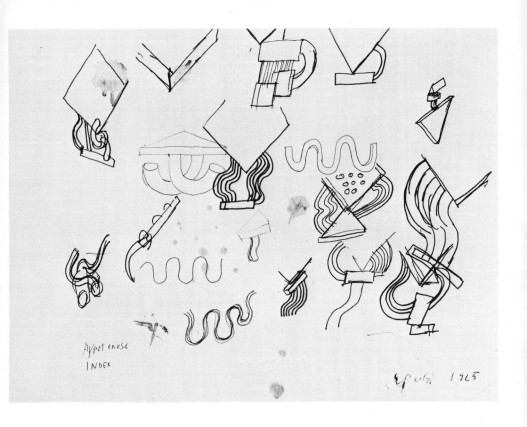

Hypotenuse Index 1965 (35)

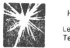

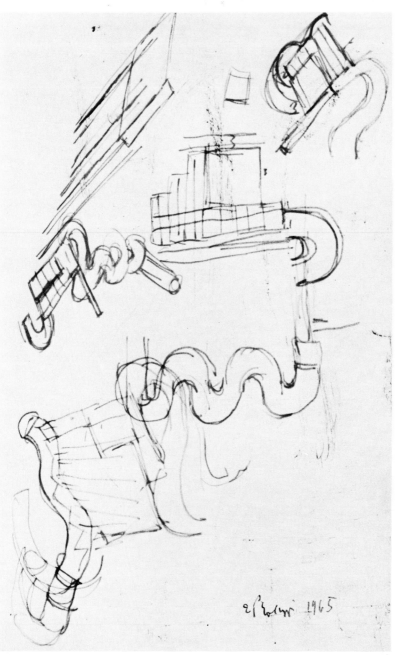

Study for sculpture 1965 (36)

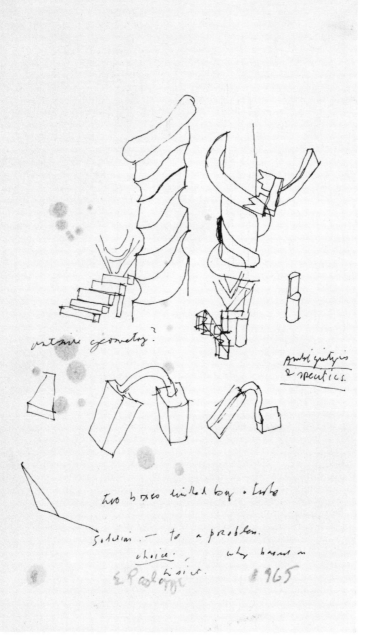

Ambiguities and specifics 1965 (37)

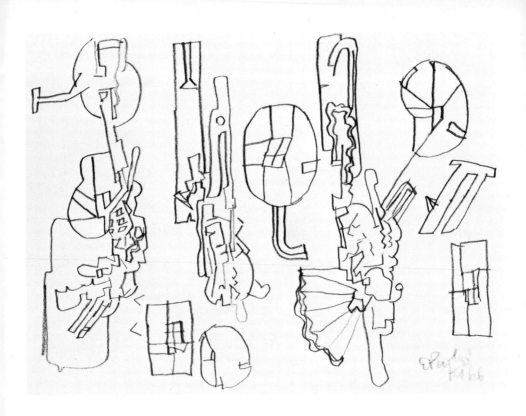

Untitled 1966 (38)

Studies 1966 (39)

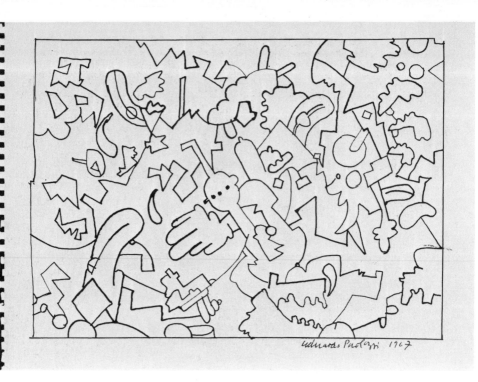

Metamorphosis of comic images 1967 (42)

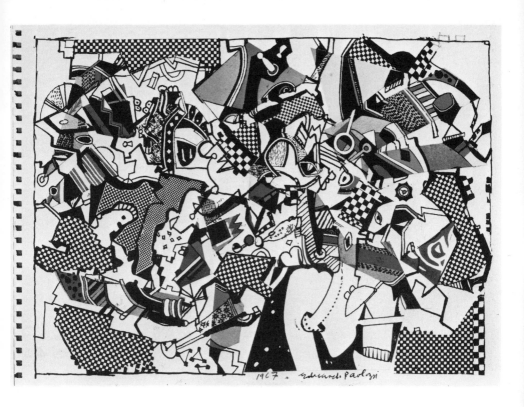

Metamorphosis of comic images in colour 1 1967 (43)

Eduardo Paolozzi 1970

Sketchbook page 1970 (45)

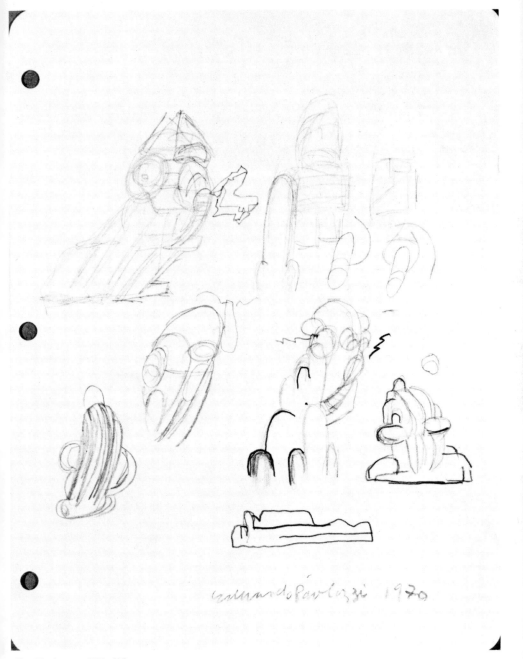

Sketchbook page 1970 (46)

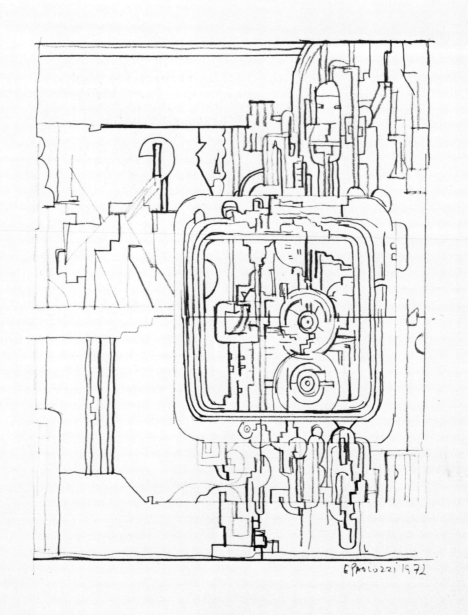

Study for Cleish ceiling panel 1972 (47)

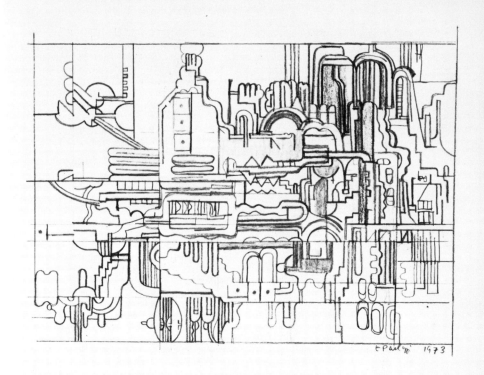

Study for Cleish ceiling panel 1973 (48)

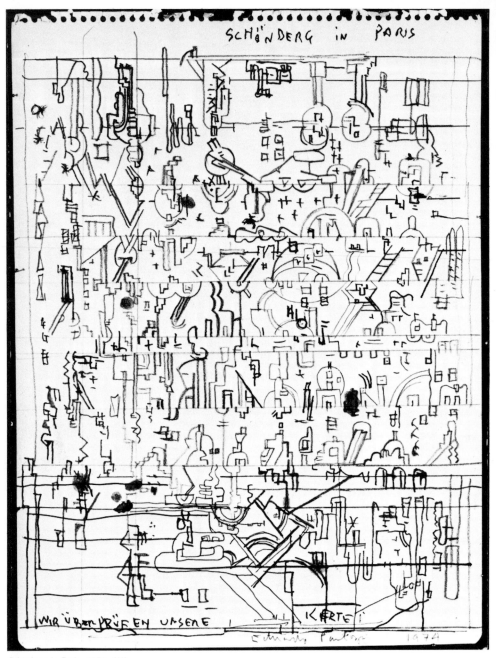

Schönberg in Paris 1974 (49)

Collages

© National Geographic Society Kodachrome, U. S. Army Air Forces, Official

A Flying Tribute to Its Builders and Ground Crew Was "Nine O Nine"

This B-17 flew more than 100 missions. Its name came from the last three digits of its serial number. At an English base a ground-crew man adds another bomb to the rows signifying missions completed; others work on chin turret and engine. With peace, thousands of such craft became winged white elephants.

1

From Bunk 1950 and 1972

From Bunk 1950 and 1972

From Bunk 1950 and 1972

From Bunk 1950 and 1972

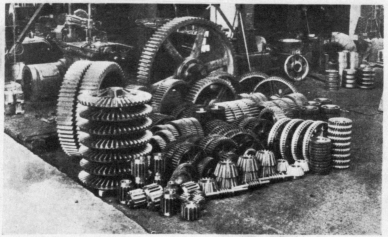

Photo, Dominion Bridge Co., Ltd., Montreal

MACHINE-CUT STRAIGHT TOOTH GEARS awaiting assembly in machines. Towards the back of the group are spur wheels of the ordinary and of the bevel types ; at the front are ordinary and bevel pinions. In front of the bevel pinions are three worms, which are used to drive the curved-face worm wheels seen on the right.

[1882 - 1957]

Fig. 5 *Volutes for Napier aero engine supercharger. (Published by kind permission of D. Napier & Son Ltd.)*

TOYS FROM THE QUEEN'S DOLLS' HOUSE.

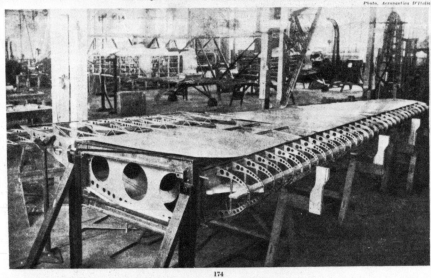

TAPERED MAIN PLANE of a Fiat stressed skin monoplane under construction in Italy. It has two heavy girder spars that run out to the tip, ribs that are pressed out of flat duralumin and sheet metal covering panels stiffened by light channel section stringers running parallel to the spars. These stringers are riveted to the inner surface of the metal skin.

Photo. Aeronautica D'Italia

174

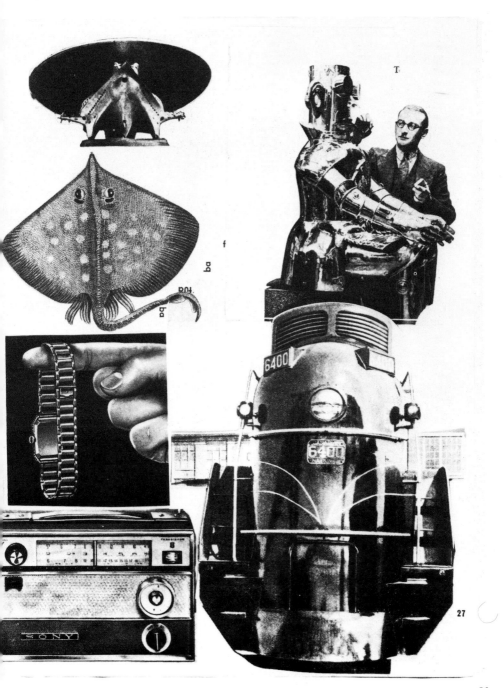

T

f

ba

ba

6400

6400

SONY

27

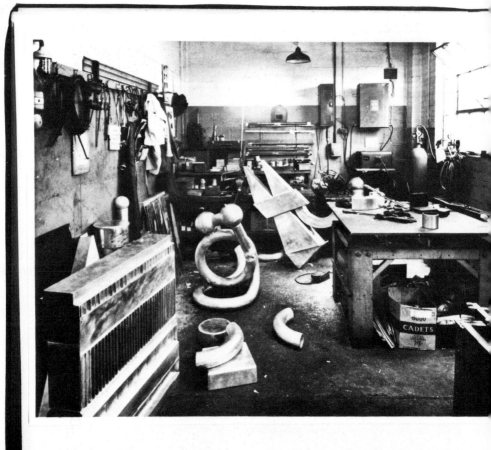

Scrapbook 1965 (53)

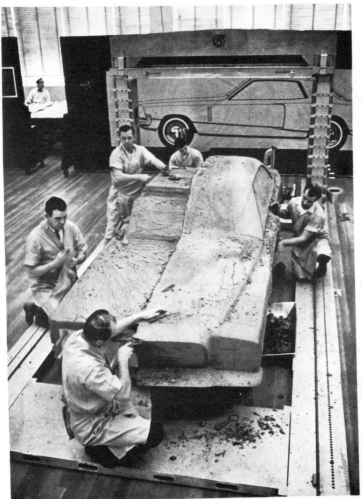

A CAR IS BORN in a styling studio outside Detroit, where sculptors work up a full-scale "dual proposal" model in clay of Mustang, Ford's new sports car. Outline drawing at rear guides man working at right; men at left will produce a proposed model differing in style concept and in trim to provide instant basis for choice between designs.

PHOTOGRAPHS FOR TIME BY J. EDWARD BAILEY

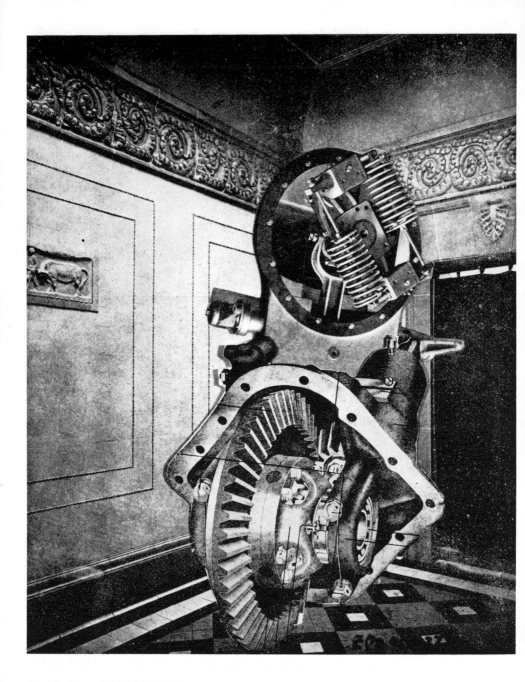

From the *History of Nothing* 1960 (55)

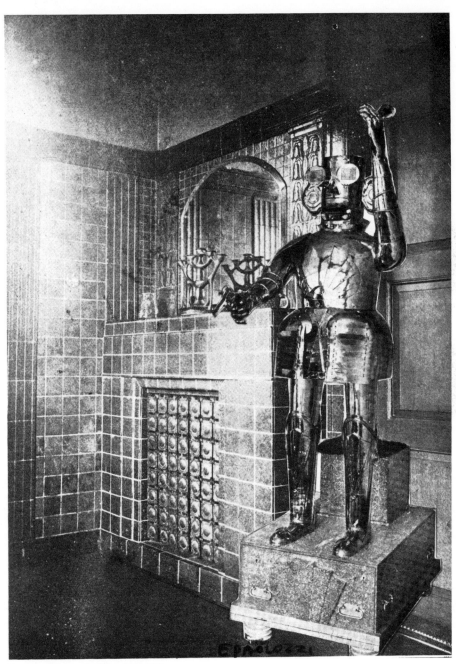

From the *History of Nothing* 1960 (55)

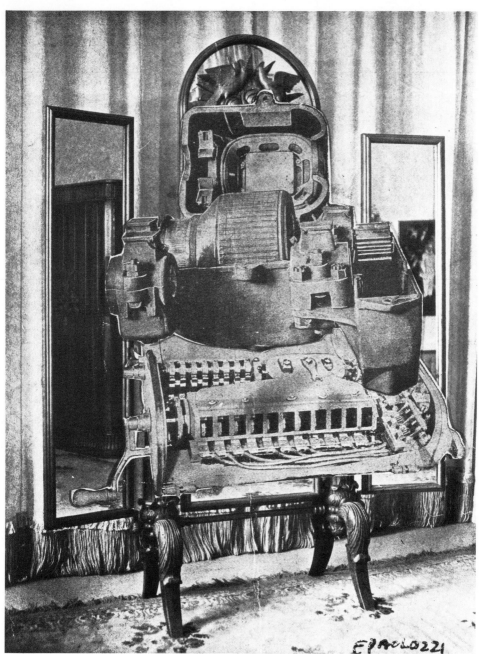

From the *History of Nothing* 1960 (55)

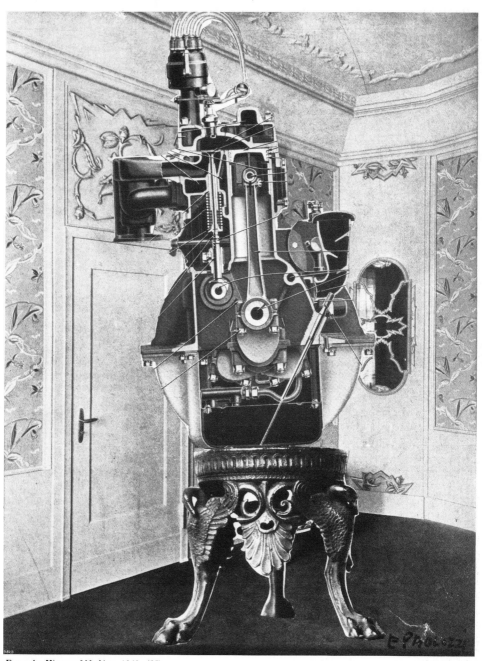

From the *History of Nothing* 1960 (55)

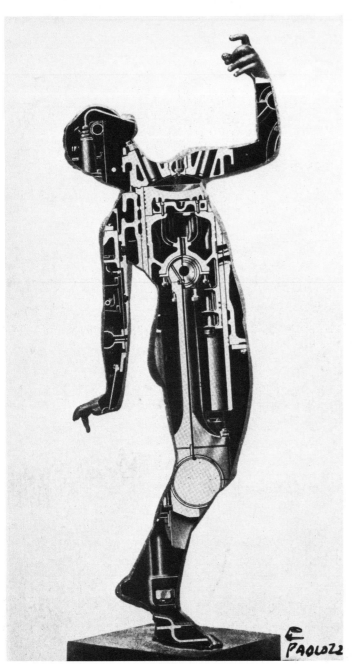

Palucca 1960 (56)

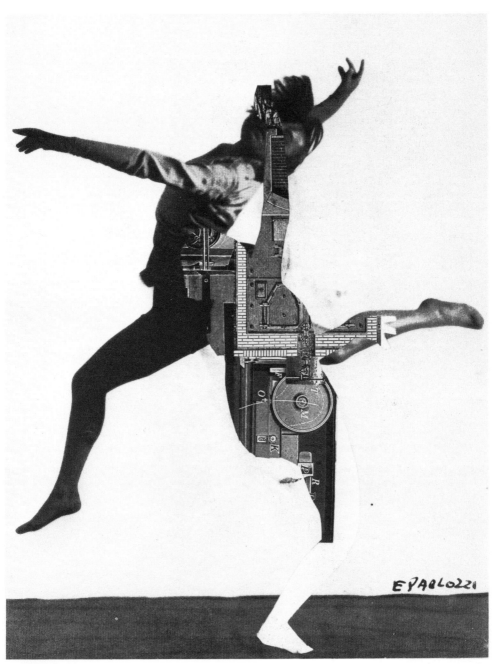

Hermaphrodit 1960 (56)

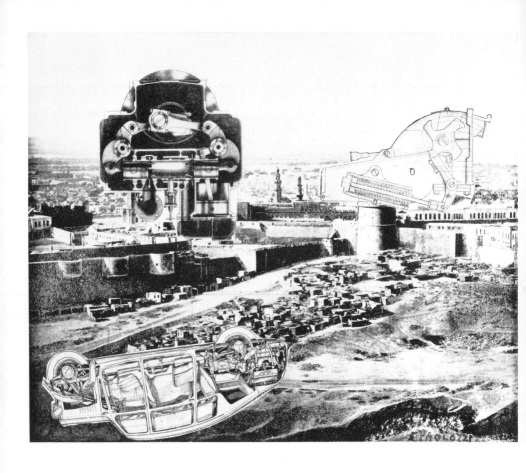

The Citadel, Cairo, Egypt From the *History of Nothing* 1960 (57)

Palace and Harem, Alexandria From the *History of Nothing* 1960 (57)

The Appian Way, Rome From the *History of Nothing* 1960 (57)

Rachel's tomb, New Bethlehem From the *History of Nothing* 1960 (57)

From the *History of Nothing* 1960 (58)

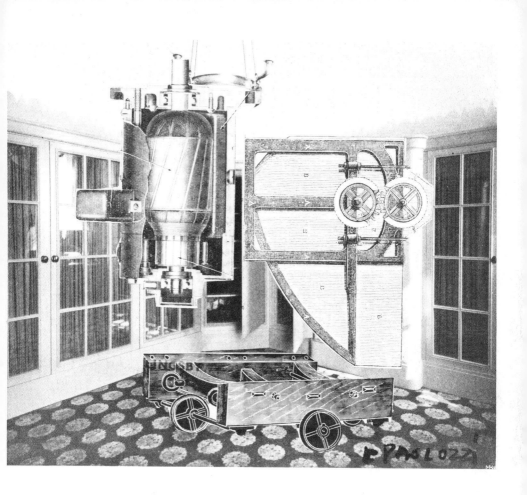

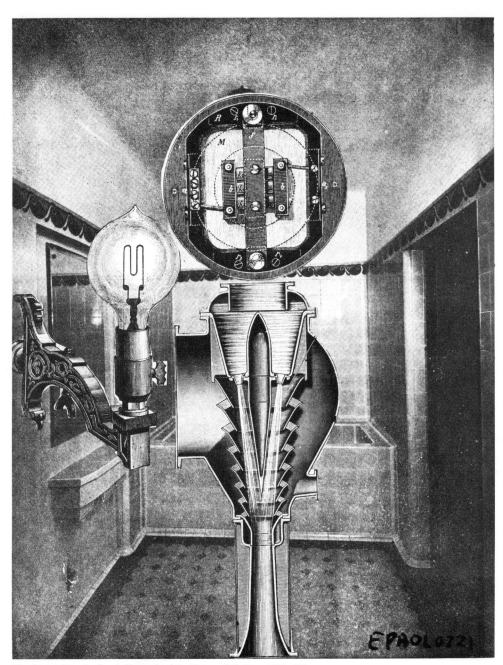

Two images from the Bench film work of the *History of Nothing* 1960 (59)

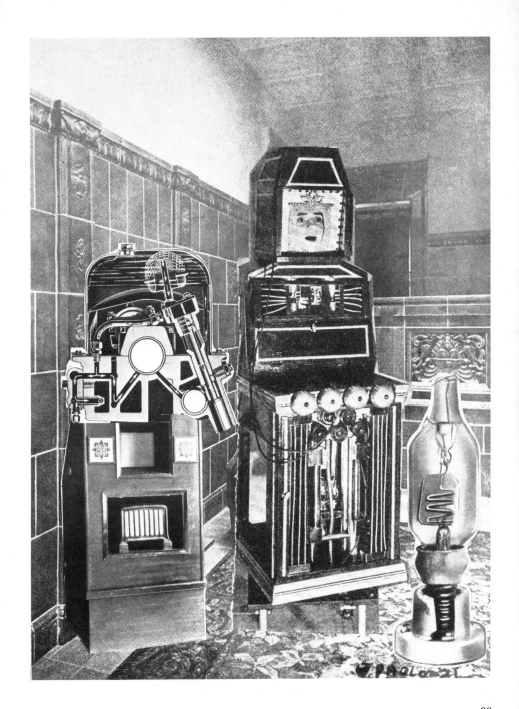

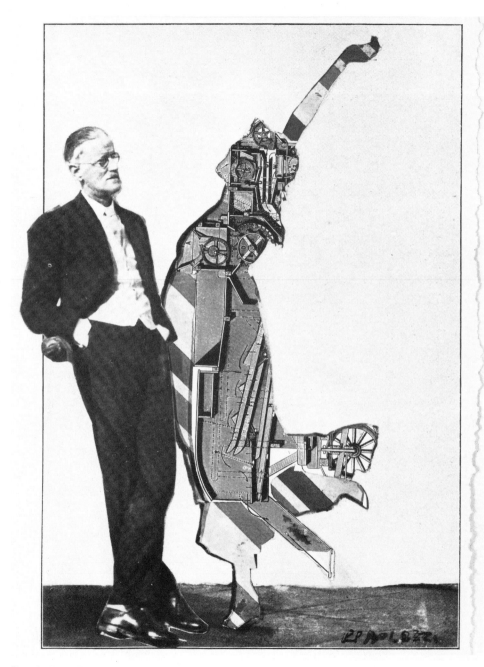

From the Bench film work for the *History of Nothing* 1960 (54)

Graphics

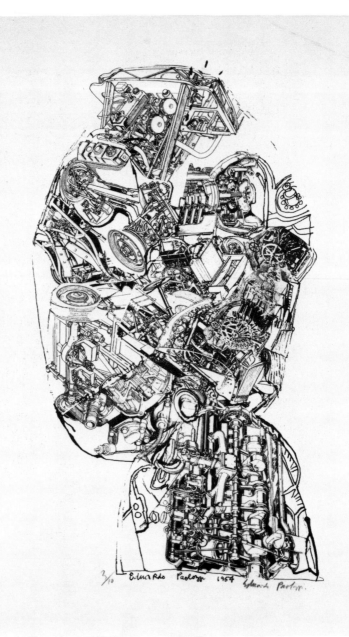

Automobile Head 1954 (61)

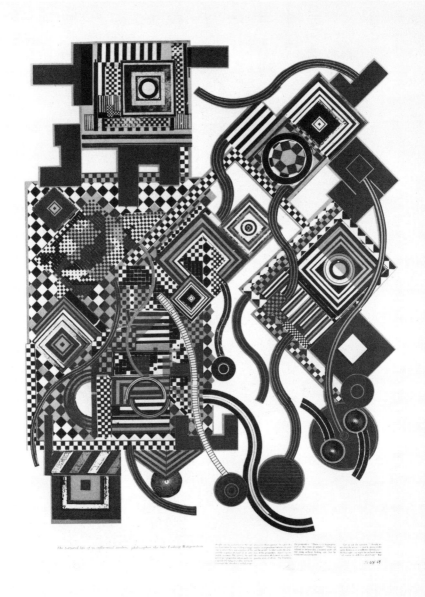

Tortured Life As is When 1965 (62)

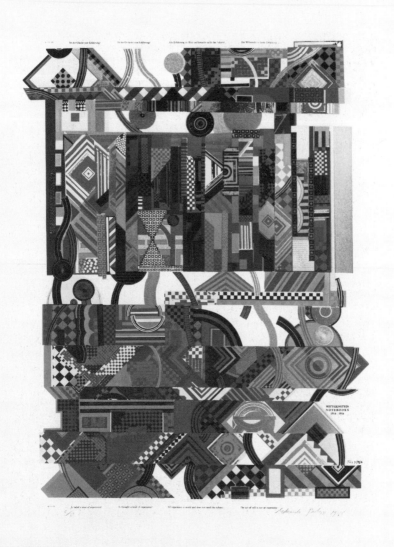

Experience As is When 1965 (62)

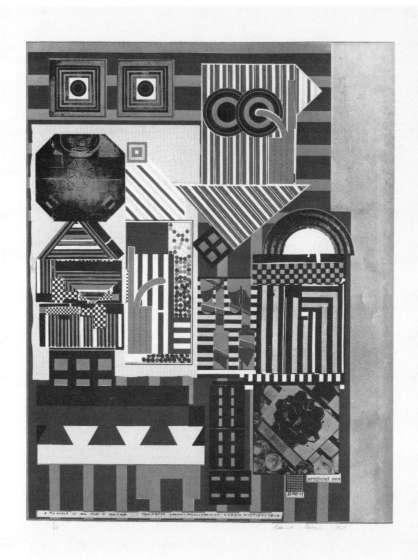

Artificial Sun As is When 1965 (62)

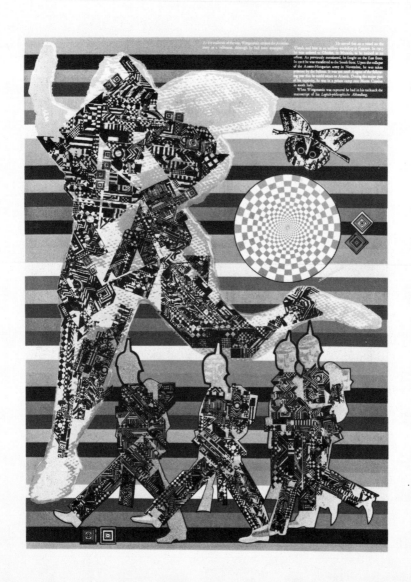

Wittgenstein as a Soldier As is When 1965 (62)

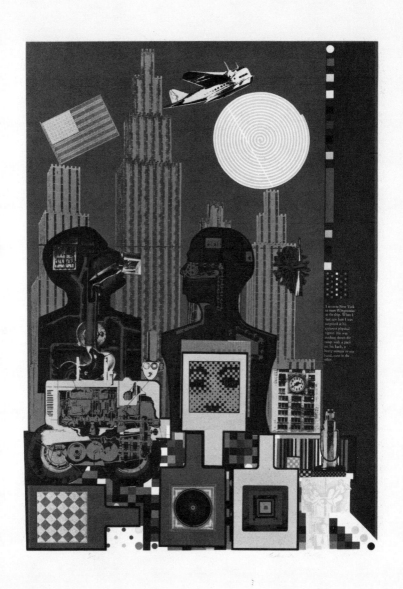

Wittgenstein in New York As is When 1965 (62)

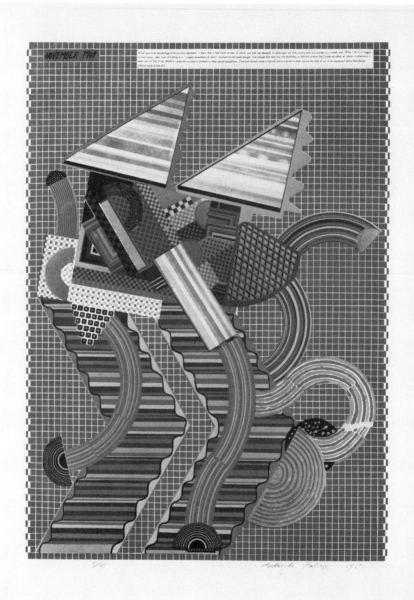

Parrot As is When 1965 (62)

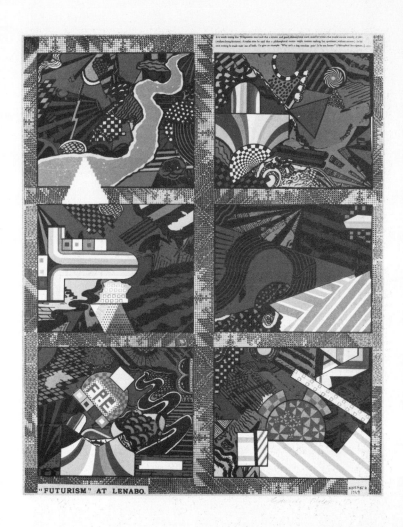

Futurism at Lenabo As is When 1965 (62)

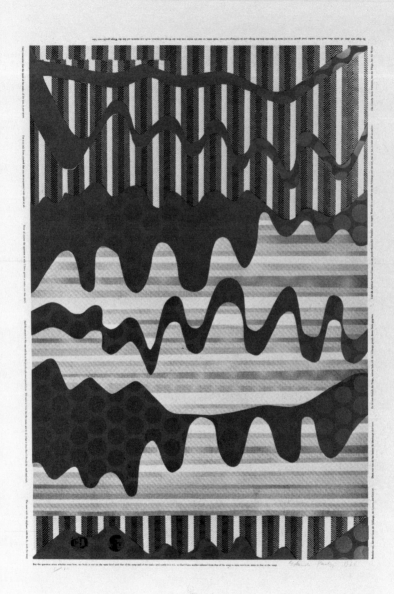

The Spirit of the snake As is When 1965 (62)

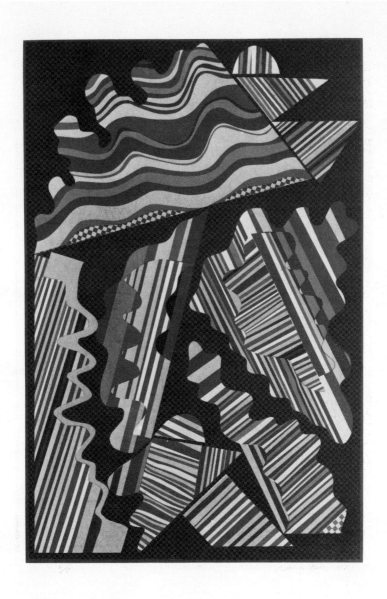

He must, so to speak, throw away the ladder As is When 1965 (62)

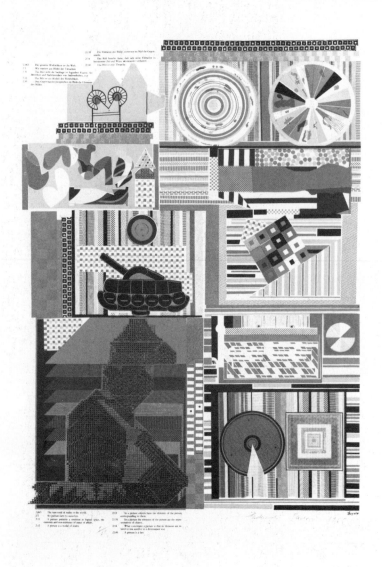

Reality As is When 1965 (62)

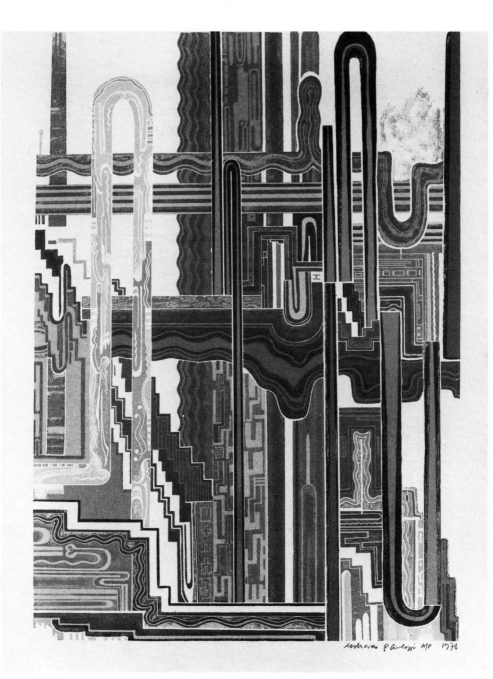

Leonardo 1974 (63)

Ci Boure The Ravel Suite 1974 (64)

Olympia The Ravel Suite 1974 (64)

Jeux D'Eau The Ravel Suite 1974 (64)

Die Versunken Glöcke The Ravel Suite 1974 (64)

Zasplak-Bat The Ravel Suite 1974 (64)

Aranjuex The Ravel Suite 1974 (64)

Türkische Musik Kottbusser Damm Pictures 1974 (65)

"Franko" Amsterd Kottbusser Damm Pictures 1974 (65)

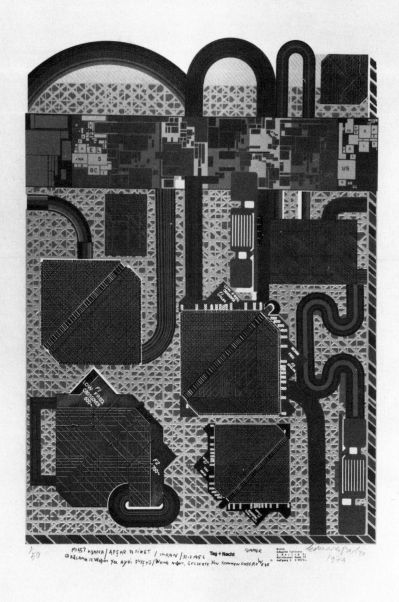

Tag + Nacht Kottbusser Damm Pictures 1974 (65)

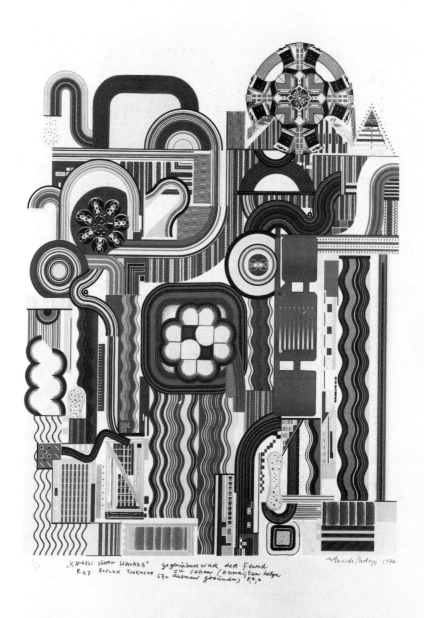

Karakus Döner Havada Kottbusser Dam Pictures 1974 (65)

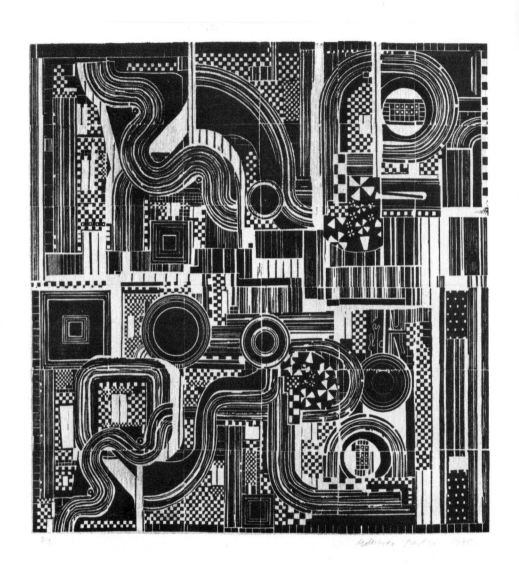

Proof for the suite: For Charles Rennie Mackintosh 1975 (66)

Catalogue

Measurements are given in centimetres, height preceding width preceding length. Unless otherwise stated sculptures, graphics and drawings are kindly loaned by Marlborough Fine Art (London) Limited and Marlborough Graphics Limited. All collages are kindly loaned by the Anthony D'Offay Gallery.

Sculptures

1 Horse's Head, 1946, Bronze, 3 casts 1974, 47.5×28.5×26.2

2 Two Forms on a Rod, 1948/49, Bronze, 51×65×32.5

3 Icarus, 1949, Bronze, 33×35.6×22.9, Martin Richmond Esq.

4 Mr. Cruikshank, 1950, Bronze, 28×29.2×20

5 The Frog, 1958, Bronze, 68.6×81.3×86.2,
 Arts Council of Great Britain

6 The Old King, 1963, Bronze, 27.9×20.3×12.1,
 Arts Council of Great Britain

7 Wittgenstein at Casino, 1963, Aluminium, painted,
 183×138.8×49.5

8 Poem for the Trio MRT, 1964, Aluminium, 216×218.4×111.8

9 Dollus II, Stainless steel, 1967, 127.6×78.7×15.2,
 Arts Council of Great Britain

10 Crash Head, 1970, Bronze, 38×26.5×21

11 Tim's Boot, 1971, Bronze, 50.8×22.9×62.2

12 Maquette for ceiling in Cleish Castle, 1972, Wood relief,
 29.8×20.3×2.5

13 Maquette for ceiling in Cleish Castle, 1972, Wood relief,
 84.5×83.5×6.4

14 Le tour du Monde, 1975, Wood relief, 4.4×32.1×4.4

15 Zutrubars, 1975, Wood relief, 22.9×9.5×1.9

16 Malduq, 1975, Wood relief, 21×6.7×1.9

17 Acarett, 1975, Wood relief, 35.9×18.4×3.2

18 Moniz, 1975, Wood relief, 45.1×19×3.8

19 Gas Taut, 1975, Wood relief, 25.1×9.8×2.5

Drawings

20 Study for standing sculptures, 1949, Pen and ink, 37.7×44.7

21 Man smoking, 1954, Pen, ink and gouache, 31×25,
 Private collection

22 Girl's Head, 1954, Pen and ink, 37.5×27,
 Arts Council of Great Britain

23 Frog, 1958, Pencil and collage, 35.2×29.6, Private collection

24 Aluminium Structures, 1964, Indian ink, 24.8×32.4

25 Variations from Mickey Mouse, 1964, Indian ink, 24.8×32.4

26 Light fighting in Shaftesbury Avenue, 1964, Ink, 33×20.2,
 The Artist

27 A possibility, 1964, Ink, 29.7×21, The Artist

28 Two bags of castings, June 25 and July 1, 1964, Biro, 33×20.2,
 The Artist

29 Waiting for the unexpected, 1964, Pencil and biro, 7.9×24.5,
 The Artist

30 Pieces born of necessity, June 27, 1964, Ink and biro, 25×35.4,
 The Artist

31 Castings assembled for box for crash, July 2, 1964, Pencil and biro,
 33×20.2, The Artist

32 Notes on the origins of my materials, 1964, Pencil and ink,
 7.8×25.7, The Artist

33 Study for sculpture, 1965, Ink, 25.3×35.5, The Artist

34 Tree, 1965, Ink and pencil, 25.4×20.2, The Artist

35 Hypotenuse Index, 1965, Biro and ink, 25.5×35.3, The Artist

36 Study for sculpture, 1965, Pencil, 34.5×21.8, The Artist

37 Ambiguities and specifics, 1965, Ink, 33×20.2, The Artist

38 Untitled, 1966, Pencil and ink, 7.7×25.7, The Artist

39 Studies, 1966, Pencil, 7.7×24.5, The Artist

40 Structures and image, 1966, Ink, 23.1×12.5, The Artist

41 Box and tubes, 1966, Pencil, 25.4×7.6, The Artist

42 Metamorphosis of comic images, 1967, Ink, 35.5×25.3,
 The Artist

43 Metamorphosis of comic images in colour 1, 1967, Ink with collage,
 35.5×25.3, The Artist

44 Metamorphosis of comic images in colour 2, 1967, Ink with collage,
 35.5×25.3, The Artist

45 Sketchbook page, 1970, Pencil, 27.8×21.5, The Artist

46 Sketchbook page, 1970, Pencil and ink, 27.8×21.5, The Artist

47 Study for Cleish ceiling panel, 1972, Pencil, 27.9×22.2

48 Study for Cleish ceiling panel, 1973, Pencil and crayon,
 20.3×28.6

49 Schönberg in Paris, 1974, Pen and pencil, 24×32.1

50 Scrapbook, 1952-4, with collaged pages over *Crane and Hoist
 Engineering by Shaw Box*, 28.5×22, The Artist

51 Scrapbook, 1961-2, with collaged pages, 23.9×23.9, The Artist

52 Scrapbook, 1961-2, with collaged pages over *Typographica* New
 Series No 3, 27.4×21, The Artist

53 Scrapbook, 1965, with collaged pages, 30.3×26, The Artist

Collages

54 Bench film work from the *History of Nothing*, 1960, 18.8×14.1

55 Four images from the Bench film work from the *History of Nothing*, 1960, 21.8×15.8 (69), 19.8×15.8 (41), 21.8×15.8 (33), 19.8×15.8 (51)

56 Collages of two figures, 1960, Palucca 18.7 × 14.4, Hermaphrodit 17.8×9.5

57 Four images from the Bench film work of the *History of Nothing*, 1960,
 The Citadel, Cairo, Egypt, 20.2×25.4
 Rachel's tomb, New Bethlehem, 20.2×25.4
 The Appian Way, Rome, 20.5×25.4
 Palace and Harem, Alexandria, 20.2×25.4

58 Two images from the Bench film work of the *History of Nothing*, 1960, each 12.2×14.6

59 Two images from the Bench film work of the *History of Nothing*, 1960, 21.8×16.3 and 19.3×14.4

60 Collage over African Sculpture, 1960, 25.5×14.9

Graphics

61 Automobile Head, 1954, Silkscreen, edition of 10, 63.2×50.5, Martin Richmond, Esq.

62 As is When, 1965, Silkscreen, series of 12 prints, edition of 65, 81.3×55.9, Published by Editions Alecto, printed by Kelpra Studio, Private Collection
 a Poster
 b Artificial Sun
 c Tortured Life
 d Reality
 e Experience
 f Wittgenstein as a Soldier
 g Wittgenstein in New York
 h Parrot
 i Futurism at Lenabo
 j Assembling Reminders for a particular purpose
 k The Spirit of the snake
 l He must, so to speak, throw away the ladder
 m Wittgenstein at the Cinema admires Betty Grable

63 Leonardo, 1974, Silkscreen, edition of 96, 65.1 × 50, Published by Marlborough Graphics Limited for Grafik International, Stuttgart

64 The Ravel Suite, 1974, Etching, edition of 15, 50.8 × 38.1, Published by Marlborough Graphics Ltd., printed by White Ink Studios
 a Ci Boure
 b Jeux D'Eau
 c Olympia
 d Die Versunken Glöcke
 e Aranjuex
 f Zasplak-Bat

65 Kottbusser Damm Pictures and Turkish Music, 1974, Silkscreen, series of 4 images, edition of 50, 97.5×72.5, Published by Marlborough Graphics Ltd., printed by Kelpra Studio
 a Türkische Musik
 b "Franko" Amsterd
 c Tag + Nacht
 d Karakus Döner Havada

66 Proof for the suite: For Charles Rennie Mackintosh, 1975, 64.9×65.4, For the four, Woodcut, Published by Marlborough Graphics Ltd., printed by White Ink Studios

Tapestry

67 Tapestry, 1966, Made by the Atelier Pinton Frères, 193×132, The Trustees of the Tate Gallery

Film

The History of Nothing, 1962, 1960-62, 16mm, Black and White, 14 mins, by Eduardo Paolozzi & Dennis Postle

Mr. Machine, 1972, 16mm, Black and White, 15min, made by Peter Leake & Keith Griffiths

Slide sequences

 a *Bunk*, the collages presented by Paolozzi at the ICA in 1952
 b *Scrapbook*, the spreads from catalogue number 50

Photographic credits:
J P Anders p 102; Arts Council of Great Britain, pp 11 (top), 44, 45, 48, 57; N J Cotterell pp12 (bottom), 17, 47; Prudence Cuming pp 6, 20, 23 (top), 43, 49, 50-54, 72-79, 103-124; David Farrell p 10 (top); Reinhard Friedrich pp 2, 14; Radio Times Hulton Picture Library pp 8, 9 (top), 10 (bottom); St Andrews University pp 15, 16; John Webb pp 21, 23 (bottom), 26, 60-71, 80-100; Rodney Wright-Watson pp 9 (bottom), 13 (top), 42, 46, 58, 59